COOL SHOPS
Hong Kong

teNeues

Imprint

Editors: Anna Koor, Désriée von la Valette, Katharina Feuer

Editorial coordination: Katharina Feuer

Photos (location): Stuart Woods (Aesop Concept Store), Julius Fan (Arnhold Designer Gallery), Panorama International Ltd (Artistic Palace), Joe Cheung (Barrie Ho Collections), Hai (Basheer Design Books), Jolans Fung (Bloomsbury Bookshop), Virgile Simon Bertrand (Dialogue, Emphasis Jewellery, Libre!, Swank), Ramon Prat (Emporio Armani Chater House), Joseph Sy (Eu Yan Sang), Courtesy Evisu (Evisu, ifc mall), Bore Wong (Galerie Vee), John Butlin (GOD, Momento), Courtesy Atelier Pacific (Graham 32), Tsang Tak-ping (Habitus), William Furniss (Harvey Nichols Store), Courtesy I.T Pacific Place (I.T Pacific Place), Joyce Boutique Holdings Ltd (Joyce), Aston Law (KOU), Courtesy Lane Crawford (Lane Crawford, ifc mall), Courtesy Louis Vuitton Hong Kong (Louis Vuitton), Tony Luk (Louvre Gallery), Graham Uden (Maybach Centre of Excellence), Courtesy On Pedder (On Pedder), Courtesy OVO Garden (OVO Garden), Maury Wong (Pink Box Flagship Store), Eternal Optical & Perfumery (Far East) Ltd. (Prada Beauty, ifc mall), Ulso Tsang (Qeelin), Wong Ho Yin (Seibu Langham Place)

Introduction: Anna Koor

Layout & Pre-press: Katharina Feuer, Jan Hausberg

Imaging: Jan Hausberg

Translations: SAW Communications, Dr. Sabine A. Werner, Mainz
Ulrike Brandhorst (German), Brigitte Villaumié (French), Maider Olarra (Spanish), Maria-Letizia Haas (Italian)

Produced by fusion publishing GmbH, Stuttgart . Los Angeles www.fusion-publishing.com

Published by teNeues Publishing Group

teNeues Book Division
Kaistraße 18
40221 Düsseldorf, Germany
Tel.: 0049-(0)211-994597-0
Fax: 0049-(0)211-994597-40
E-mail: books@teneues.de

Press department:
arehn@teneues.de
Phone: 0049-2152-916-202

www.teneues.com

teNeues Publishing Company
16 West 22nd Street
New York, NY 10010, USA
Tel.: 001-212-627-9090
Fax: 001-212-627-9511

teNeues Publishing UK Ltd.
P.O. Box 402
West Byfleet
KT14 7ZF, Great Britain
Tel.: 0044-1932-403509
Fax: 0044-1932-403514

teNeues France S.A.R.L.
4, rue de Valence
75005 Paris, France
Tel.: 0033-1-55766205
Fax: 0033-1-55766419

teNeues Ibérica S.L.
C/ Velazquez 57 6 Izd
28001 Madrid, Spain
Tel./Fax: 0034-6-57 13 21 33

ISBN-10: 3-8327-9121-3
ISBN-13: 978-3-8327-9121-6

© 2006 teNeues Verlag GmbH + Co. KG, Kempen

Printed in Italy

Picture and text rights reserved for all countries.
No part of this publication may be reproduced in any manner whatsoever.

All rights reserved.

While we strive for utmost precision in every detail, we cannot be held responsible for any inaccuracies, neither for any subsequent loss or damage arising.

Bibliographic information published by Die Deutsche Bibliothek.
Die Deutsche Bibliothek lists this publication in the Deutsche Nationalbibliografie;
detailed bibliographic data is available in the Internet at http://dnb.ddb.de.

Contents	Page
Introduction	**5**
Aesop Concept Shop	**10**
Arnhold Designer Gallery	**14**
Artistic Palace	**16**
Barrie Ho Collections	**20**
Basheer Design Books	**22**
Bloomsbury Bookshop	**28**
Dialogue	**32**
Emphasis Jewellery	**38**
Emporio Armani Chater House	**42**
Eu Yan Sang	**50**
Evisu, ifc mall	**54**
Galerie Vee	**56**
GOD	**58**
Graham 32	**60**
Habitus	**62**
Harvey Nichols Store	**66**
I.T Pacific Place	**72**
Joyce	**74**
KOU	**78**
Lane Crawford, ifc mall	**84**
Libre!	**90**
Louis Vuitton	**98**
Louvre Gallery	**102**
Maybach Centre of Excellence	**106**
Momento	**108**
On Pedder	**112**
OVO Garden	**116**
Pink Box Flagship Store	**120**
Prada Beauty, ifc mall	**122**
Qeelin	**124**
Seibu Langham Place	**126**
Swank	**130**
Map	**134**

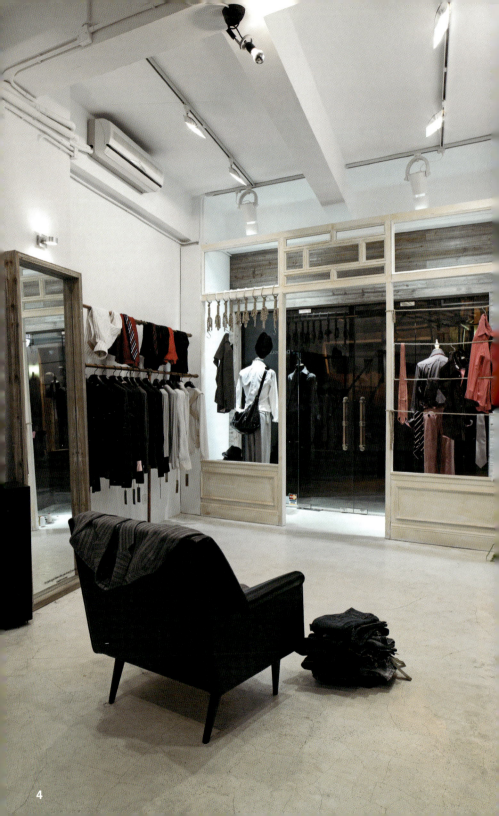

Introduction

Shopping is quite simply Hong Kong's national pastime so yield to its healing powers and don't bother trying to avoid it. Retail therapy accompanies most other activities in the city whether it's touching down at the airport, catching a movie or visiting a museum. Consumer culture has caught on big time and hours accumulated in one of Hong Kong's numerous air-conditioned retail malls define the ultimate family day out. These vast, multi-tenanted cathedrals to shopping not only feature all the world's luxury labels under one roof—think Gucci, Louis Vuitton, Prada—they provide added attractions in the form of endless entertainment. Live performances, exhibitions, chic cafes, ice-skating, bars and restaurants, cineplexes are all designed to create a multi-dimensional experience that continues well into the evening.

For those who insist on hot-footing it in Hong Kong's full-on heat and humidity, street-style shopping is thankfully experiencing a revival. Independent entrepreneurial types as well as the more edgy brand names have shunned the larger malls in favor of intimate neighborhood enclaves such as Staunton Street and Elgin Street in Soho or Paterson Street in Causeway Bay. From a visual standpoint, they can project a much stronger identity without the restrictions placed on them by stringent landlords. There are exceptions such as Langham Place, a cavernous tower which attempts to de-standardize the monotony of mall architecture, emulating the orderly chaos of the surrounding Mongkok retail-scape and the intimate complexity of Tokyo-style shopping.

With space commanding such a high premium in Hong Kong, retail designers operate at the extreme edge having to justify every millimeter of floor area and allowing nothing to detract from the product. Materials and finishes are primarily selected to withstand relentless pedestrian traffic while aesthetic charm and individuality are dovetailed against visual clarity and brand placement. Providing a stage to an ever-changing stable of 'new arrivals' requires a language that's multi-functional and modular whether it's gourmet food or fashionable footwear.

Anna Koor

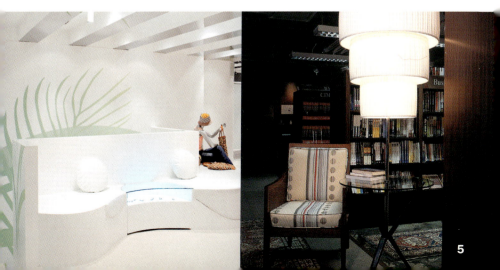

Einleitung

Shopping ist schlicht und einfach DIE nationale Freizeitbeschäftigung in Hongkong – geben Sie sich also den heilsamen Kräften dieses Zeitvertreibs hin und versuchen Sie gar nicht erst, darum herum zu kommen. Es gibt kaum eine Tätigkeit in dieser Stadt, die nicht mit der Einzelhandelstherapie verbunden wird: Ob man nun am Flughafen ankommt oder ob man ins Kino oder Museum geht – in Hongkong hat die Konsumkultur Hochkonjunktur und der ultimative Familientag besteht aus endlosen Stunden in einem der zahlreichen klimatisierten Einkaufszentren der Stadt. In diesen riesigen Einkaufskathedralen mit zahlreichen Shops aller Größen und Ausrichtungen werden nicht nur sämtliche Luxusmarken der Welt unter einem Dach angeboten – man denke an Gucci, Louis Vuitton oder Prada –, dort finden sich auch noch zusätzliche Attraktionen, so dass pausenloses Entertainment gewährleistet ist. Vorführungen, Ausstellungen, Trendcafés, Eislaufen, Bars, Restaurants und Cineplexes sorgen bis zum späten Abend für eine multidimensionale Unterhaltung.

Für diejenigen, die darauf bestehen, in der ungefilterten Hitze und Feuchtigkeit Hongkongs shoppen zu gehen, gibt es zum Glück ein Revival des klassischen Schaufensterbummels in den Straßen. Unabhängige Unternehmer und die etwas ausgefalleneren Markenanbieter meiden die großen Einkaufszentren und bevorzugen intimere Gegenden, wie z.B. die Staunton Street und die Elgin Street in Soho oder die Paterson Street in Causeway Bay. Optisch können sie hier eine viel stärkere Identität entwickeln, da sie nicht den restriktiven Bestimmungen strenger Vermieter unterworfen sind. Natürlich gibt es auch Ausnahmen unter den Malls, wie z.B. Langham Place, den ungewöhnlichen Wolkenkratzer, der die Monotonie der Shopping-Center-Architektur zu durchbrechen sucht und die geordnet chaotische Silhouette der Einkaufszentren von Mongok und die intime Komplexität der Tokioter Shopping-Szene nachahmt.

Raum ist in Hongkong ein Luxusgut und die Shop-Designer müssen jeden Quadratmillimeter der Geschäfte optimal nutzen – nichts darf vom Produkt ablenken. Die komplette Innenausstattung wird vornehmlich danach ausgesucht, dass sie dem unablässigen Kundenstrom standhält – Ästhetik, Charme und Individualität werden auf visuelle Klarheit in der Produkt- und Markenplatzierung ausgerichtet. Um dem immer wechselnden Reigen neuer Produkte eine Plattform zu bieten, braucht man ein multi-funktionales und modulares Medium, das flexibel eingesetzt werden kann – ganz gleich, ob es sich nun um kulinarische Angebote handelt oder um modisches Schuhwerk.

Anna Koor

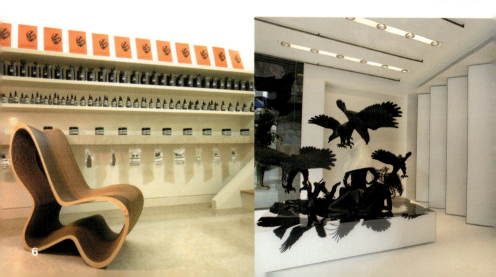

Introduction

Le shopping est tout simplement LE hobby national à Hong Kong – abandonnez-vous à la force d'attraction salutaire de ce passe-temps et n'essayez surtout pas de vous y soustraire. Il n'y a pratiquement pas une activité dans cette ville qui ne soit liée à la thérapie du commerce de détail : que vous arriviez à l'aéroport, que vous alliez au cinéma ou au musée, à Hong Kong, la culture de la consommation est très florissante et le nec plus ultra de la journée des familles consiste à passer d'interminables heures dans l'un des nombreux centres commerciaux climatisés de la ville. Dans ces immenses temples du commerce aux innombrables boutiques de toutes les tailles et de tous les styles, s'offrent à vous, sous un même toit, non seulement la totalité des marques de luxe du monde entier – telles que Gucci, Louis Vuitton ou Prada – mais aussi des attractions supplémentaires qui assurent une animation permanente. Démonstrations, expositions, cafés tendance, patinage sur glace, bars, restaurants et cinéplexes vous garantissent un divertissement multidimensionnel jusque tard dans la soirée.

Pour ceux qui s'obstinent à vouloir magasiner dans la touffeur et l'humidité viciée de Hong Kong, il existe heureusement une renaissance du classique lèche-vitrines dans les rues. Des entrepreneurs indépendants ainsi que les fournisseurs de marques plus excentriques évitent les grands centres commerciaux et privilégient les quartiers plus intimes, tels que la Staunton Street et l'Elgin Street à Soho ou la Paterson Street de la Causeway Bay. Visuellement, ils peuvent s'y forger une identité beaucoup plus forte car ils ne sont pas soumis aux dispositions restrictives de propriétaires rigoureux. Bien sûr, il y a des exceptions parmi les « Malls » comme par ex. Langham Place, ce gratte-ciel insolite qui tente de rompre la monotonie de l'architecture des centres commerciaux en imitant la silhouette de chaos organisé des centres commerciaux de Mongok et la complexité intime de la scène du shopping tokyote.

L'espace à Hong Kong est un bien de luxe et les concepteurs de boutiques doivent exploiter au mieux chaque millimètre carré de surface de magasin – rien ne doit distraire l'attention du produit. L'ensemble de la décoration intérieure est avant tout sélectionné pour résister au flux continuel des clients – l'esthétique, le charme, l'individualité se traduisent par la clarté visuelle du placement des produits et des marques. Pour offrir une plate-forme à la ronde incessante des nouveaux produits, il faut disposer d'un support multifonctionnel et modulaire qui puisse être employé de façon flexible – que ce soit pour présenter une offre culinaire ou une chaussure de mode.

<div style="text-align: right;">Anna Koor</div>

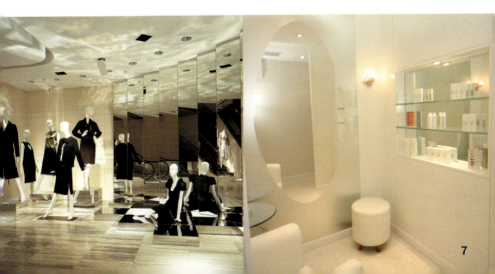

Introducción

En Hong Kong ir de compras es sencillamente el deporte nacional. Así es que no se resista, entréguese a esta forma de pasar el tiempo y disfrute de su poder revitalizante. En esta ciudad apenas existe una actividad que no esté relacionada con la terapia del comercio. Ya sea al llegar al aeropuerto, o al ir al cine o a un museo, en Hong Kong la cultura del consumismo disfruta de la coyuntura al máximo. La idea de un día familiar ideal es sinónimo de pasar horas interminables en uno de los numerosos centros comerciales climatizados de la ciudad. En estas catedrales del consumo repletas de comercios de todas las dimensiones y tipos no sólo se venden las más diversas marcas internacionales de lujo bajo un mismo techo, sea Gucci, Louis Vuitton o Prada, sino que allí además se encuentran otro tipo de atracciones que garantizan el ocio sin pausa: representaciones, exposiciones, cafeterías de moda, pistas de patinaje sobre hielo, bares, restaurantes y multicines abiertos hasta última hora de la tarde, que regalan diversión en todas sus facetas.

Afortunadamente, para quienes insistan en ir de compras sin disfrazar el auténtico calor y humedad de Hong Kong también hay en las calles una copia típica del clásico ambiente de escaparates. Los comerciantes individualistas y representantes de marcas algo más extravagantes, evitan los centros comerciales y buscan entornos más íntimos, como Staunton Street y Elgin Street en Soho, o bien la Paterson Street en Causeway Bay. Desde el punto de vista óptico estos comercios disfrutan de una mayor identidad ya que no se tienen que ajustar a las normas de arrendadores más estrictos. Por supuesto que entre los centros comerciales también hay excepciones, como en el caso de Langham Place, un atípico rascacielos que rompe con la habitual monotonía de la arquitectura del Shopping-Center e imita la línea de orden caótico de centros como el de Mongok y la complejidad íntima del ambiente comercial de Tokio.

En Hong kong el espacio es un bien de lujo. Lo que obliga a los diseñadores de comercios a aprovechar cada milímetro, haciendo del producto el centro de atención. Todo el equipamiento interior es seleccionado cuidadosamente a fin de hacer frente el constante flujo de clientes. Estética, encanto e individualidad están enfocados a proporcionar la transparencia visual y ubicación de la marca. Para poder ofrecer un soporte a la continua entrada de nuevos productos es necesario un medio multifuncional y modular que se pueda emplear de forma flexible, ya se trate de oferta culinaria o calzado de moda.

<div align="right">Anna Koor</div>

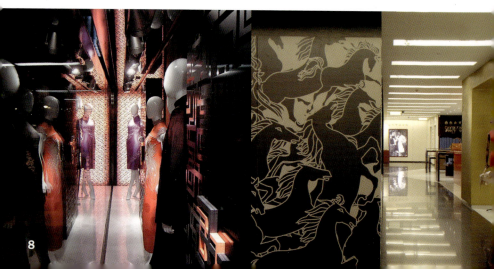

Introduzione

A Hong Kong lo shopping è semplicemente l'hobby nazionale per antonomasia: non crediate, quindi, di riuscire ad evitarlo, ma abbandonatevi piuttosto ai salubri effetti di questo passatempo. A Hong Kong non esiste attività che non sia collegata agli effetti terapeutici del commercio al dettaglio: che si giunga all'aeroporto, si vada al cinema o si visiti un museo, qui il culto del consumo gode di largo consenso; basti pensare alla giornata-tipo di una famiglia, che consiste in ore e ore trascorse in uno dei numerosi centri commerciali climatizzati della città. In questi immensi magazzini, che ospitano innumerevoli negozi di tutti i tipi e di tutte le dimensioni, non solo vengono proposte, in un'unica struttura, tutte le marche di lusso del mondo – come Gucci, Louis Vuitton o Prada – ma ci sono anche tantissime attrazioni che garantiscono divertimento non-stop: spettacoli, mostre, locali alla moda, pattinaggio, bar, ristoranti e multisale cinematografiche offrono intrattenimento multidimensionale fino a tarda sera.

Per coloro che, invece, si ostinano a fare shopping nel caldo torrido e nell'umidità inclementi di Hong Kong, c'è la possibilità della classica passeggiata tra le vetrine delle strade del centro, di cui si assiste un fortunato revival. I commercianti autonomi e quelli che propongono articoli di marche insolite evitano i grandi centri commerciali, preferendo zone più intime, come Staunton Street o Elgin Street a Soho, oppure Paterson Street a Causeway Bay, luoghi che permettono di esprimere un'identità più accentuata dal punto di vista visivo, senza le severe restrizioni imposte dai locatori. Naturalmente, anche tra i mall ci sono le eccezioni, come ad esempio Langham Place, il singolare grattacielo che tenta di spezzare la monotonia dell'architettura degli shopping center, e che imita la silhouette ordinatamente caotica dei centri commerciali di Mongok e l'intima complessità dello scenario in cui, a Tokyo, si pratica lo shopping.

A Hong Kong, lo spazio è un genere di lusso: i designer di negozi devono utilizzare al meglio ogni millimetro disponibile, perché nulla deve distrarre dal prodotto offerto. Il primo criterio di ricerca dell'intero arredamento interno è la resistenza al flusso incessante della clientela – estetica, fascino ed individualità sono volti alla chiarezza visiva con cui i prodotti e le marche vengono proposti. Per poter offrire spazio a linee di articoli sempre nuove, occorre un mezzo modulare e multifunzionale applicabile in modo flessibile, adatto a presentare qualsiasi genere di prodotto, da quello culinario ai modelli di scarpe più attuali.

<div align="right">Anna Koor</div>

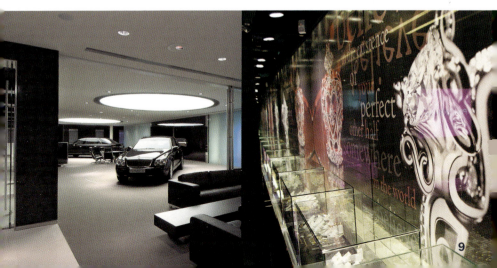

Aesop Concept Shop

Design: Jim Vitogiannis, Dennis Paphitis

G/F, 52-60 Lyndhurst Terrrace | Hong Kong | Soho, Central
Phone: +852 2544 4489
www.aesop.net.au
MTR: Central
Opening hours: Every day 11 am to 7:30 pm
Products: Aesop skin care products
Special features: Decoration by Louis Poulsen and Dune Chair

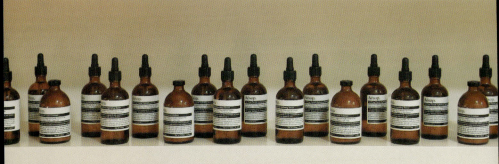

Aesop Concept Shop

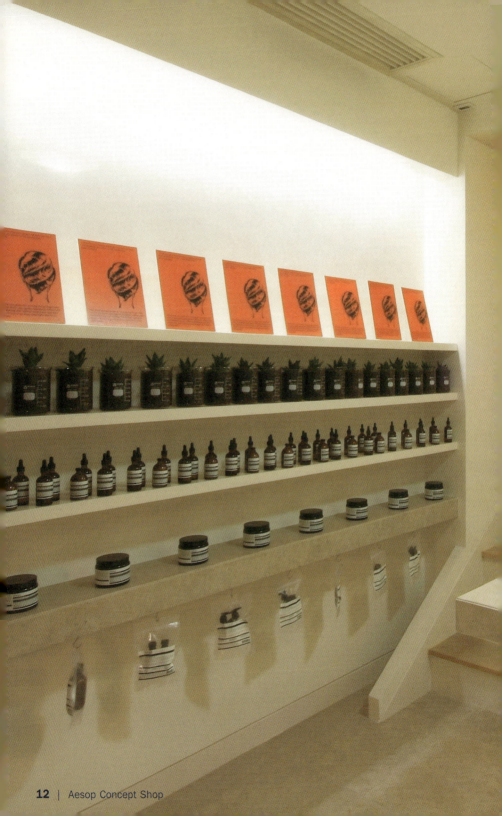

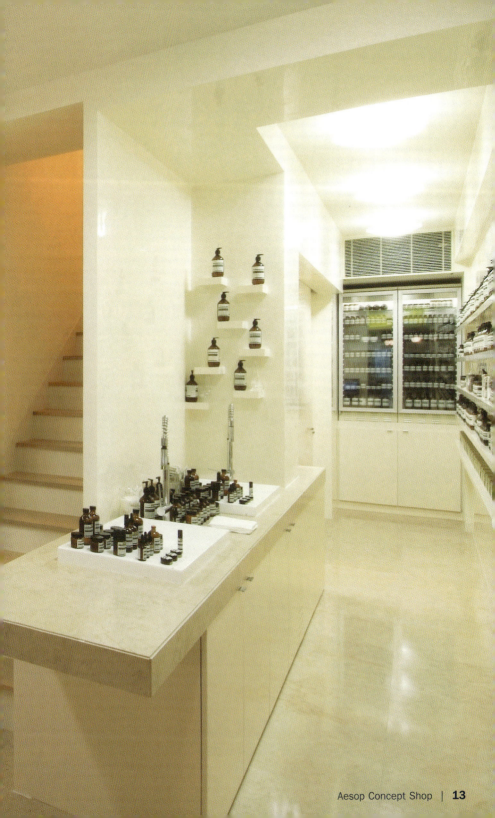

Arnhold Designer Gallery

Design: Kinney Chan & Associates

Lockhart Road | Hong Kong | Wanchai
Phone: +852 2865 0318
arndesign@arnhold.com.hk
MTR: Wanchai
Opening hours: Mon–Sat 10 am to 7 pm, Sun noon to 7 pm
Products: Sanitary wares

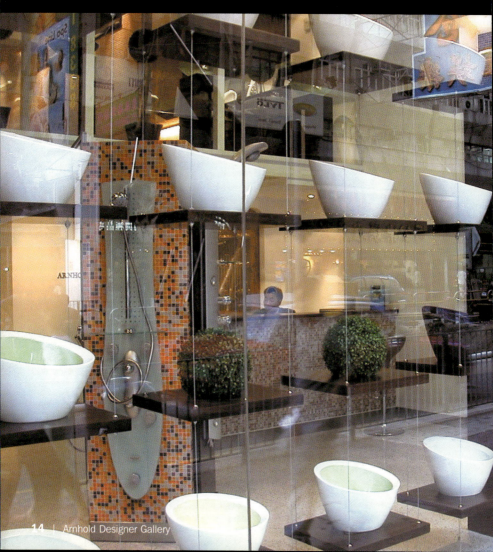

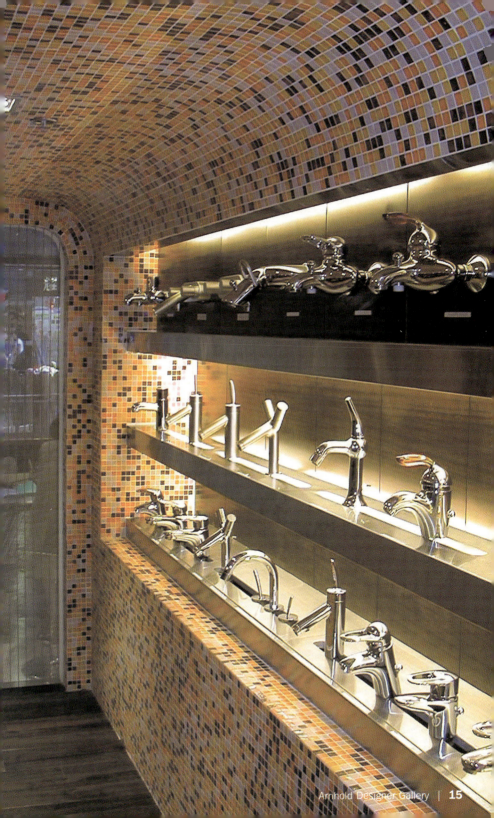

Artistic Palace

Design: Panorama International Ltd.

2/F, China Resources Building, 26 Harbour Road | Hong Kong | Wanchai
Phone: +852 2827 6667
www.crcretail.com
MTR: Wanchai Station
Opening hours: Every day 10 am to 7 pm
Products: Men's & ladies' apparel, accessories and a collection of novelty gift items

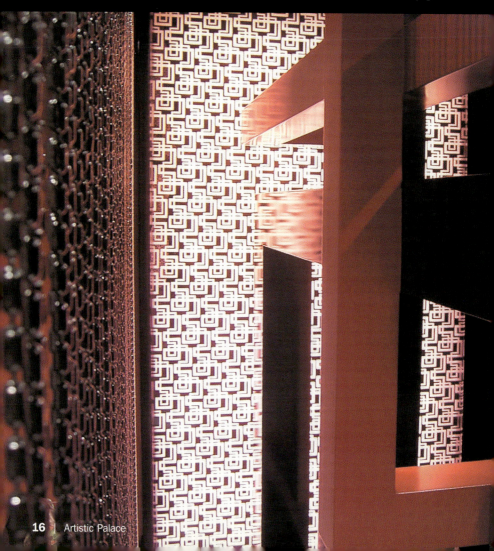

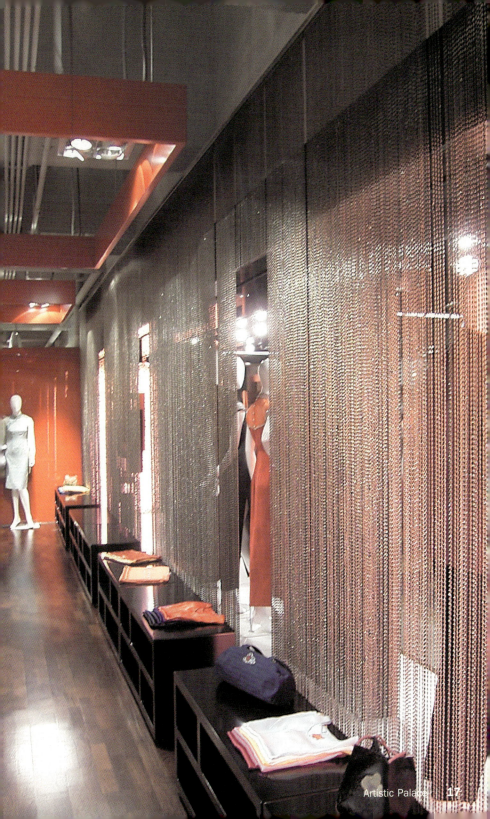

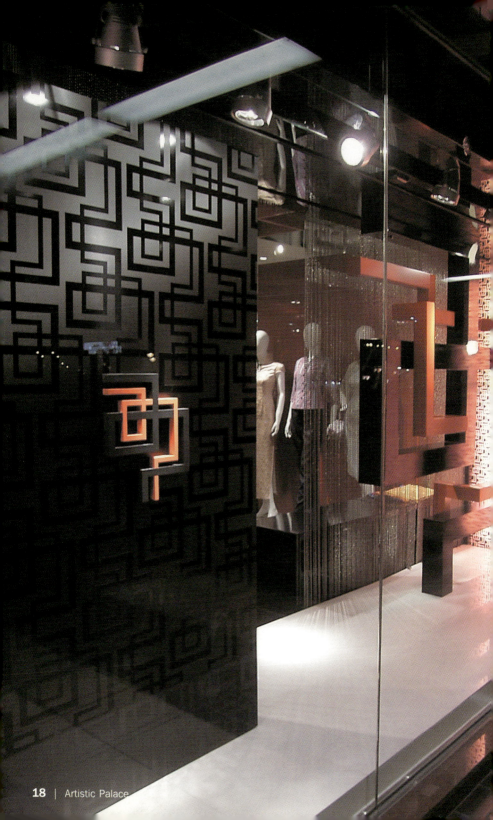

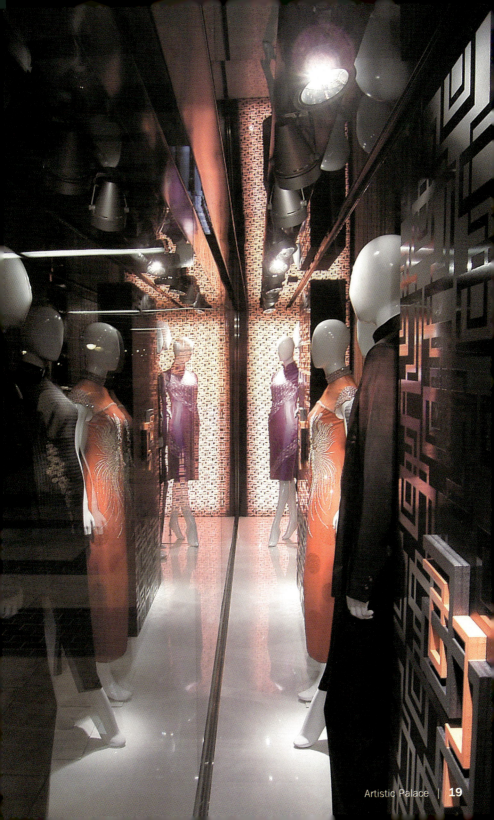

Barrie Ho Collections

Design: Barrie Ho

1/F, 31 Wyndham Street | Hong Kong | Central
Phone: +852 2117 7662
www.barrieho.com
MTR: Central
Opening hours: Every day 9:30 am to 7 pm
Products: Furniture, living accessories

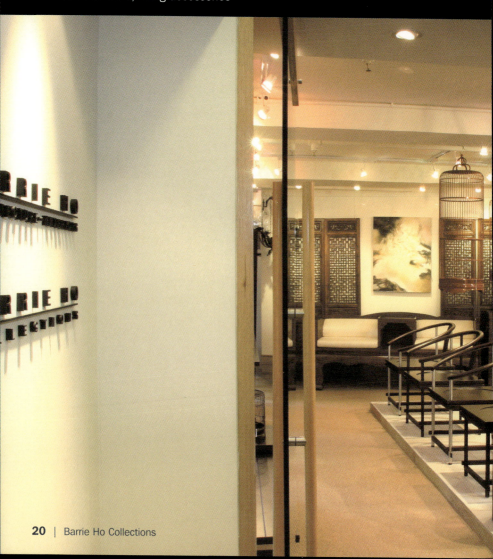

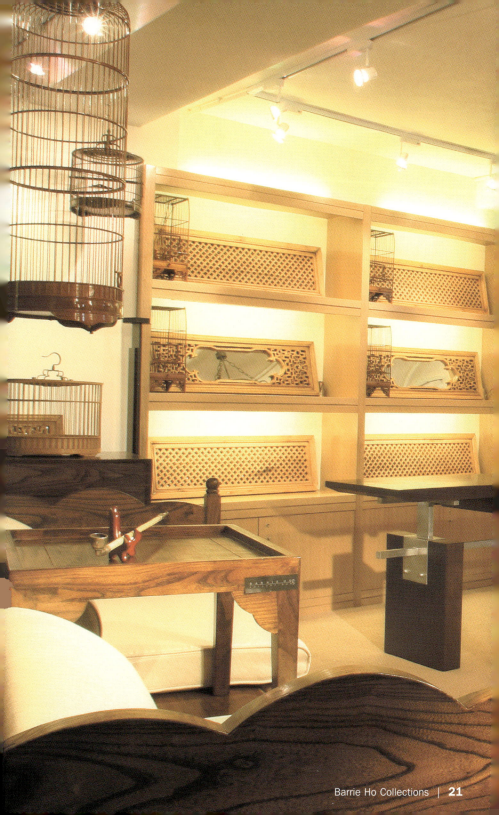

Basheer Design Books

Design: Joey Ho

1/F, Flat A Island Building, 439-441 Hennessy Road | Hong Kong | Causeway Bay
Phone: +852 2126 7533
www.basheer.com.hk
MTR: Causeway Bay
Opening hours: Every day 11:30 am to 10 pm
Products: Books on architectural design, interior design, graphic design, fashion design, advertising, art etc.
Special features: Flexible and a fixed spaces provide exhibition space

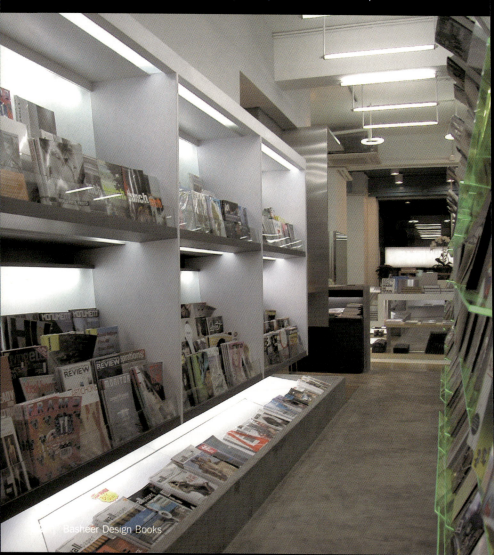
Basheer Design Books

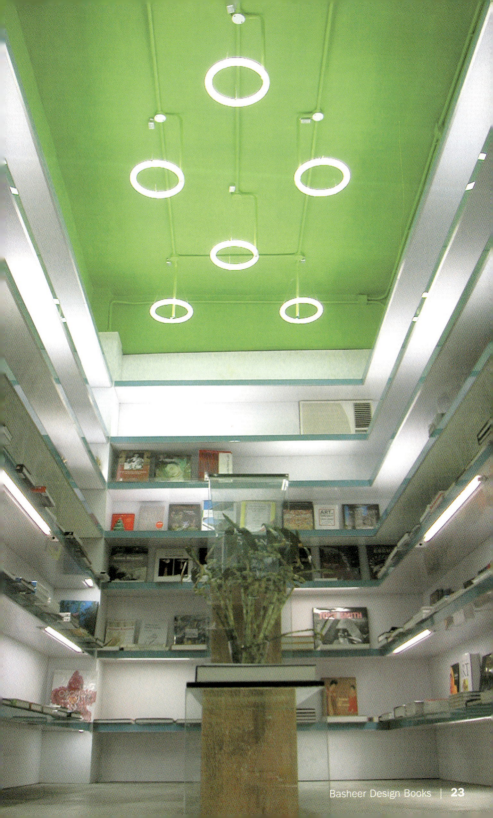

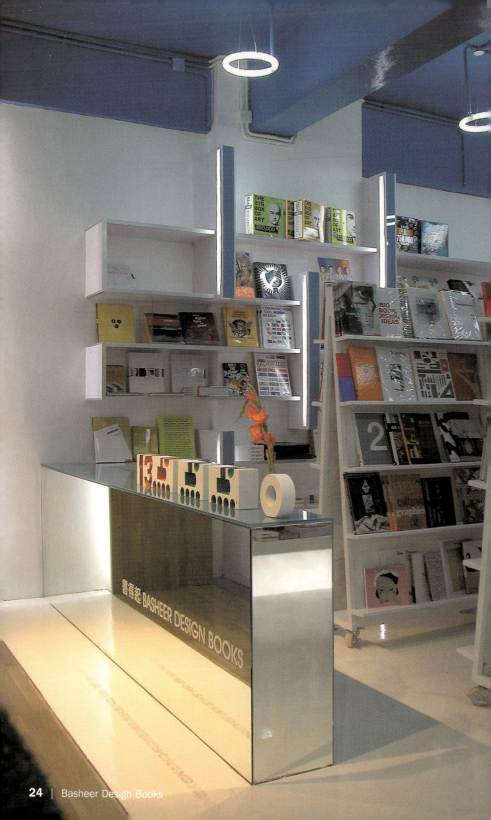

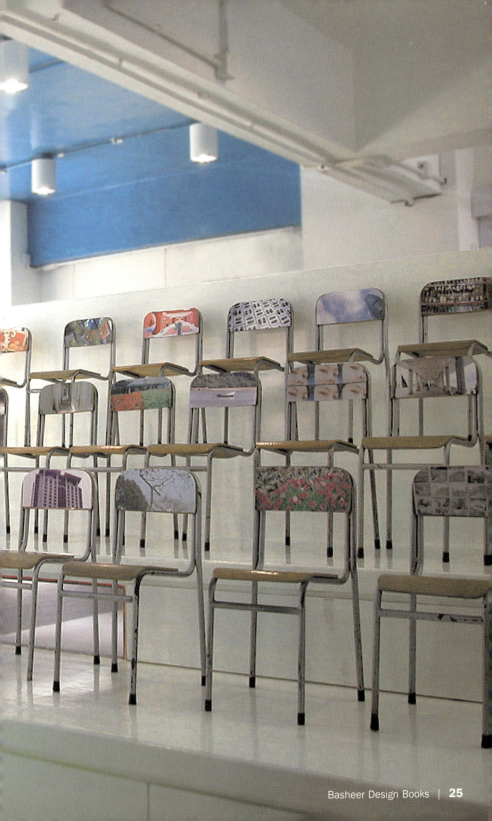

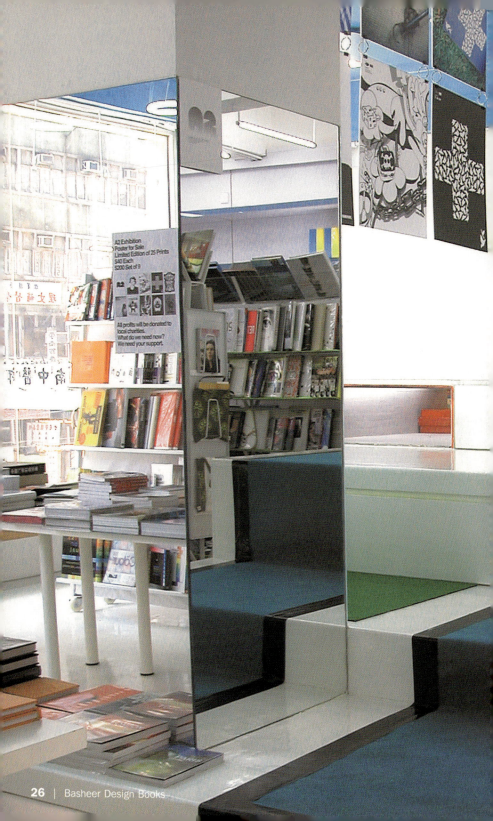

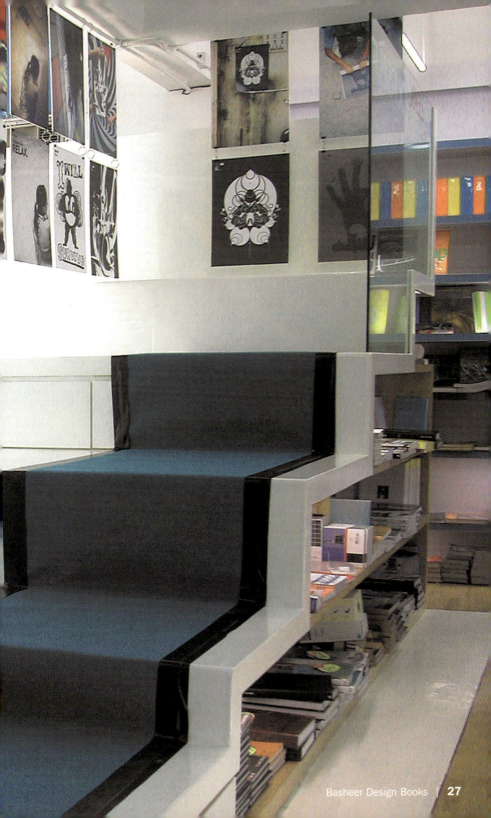

Bloomsbury Bookshop

Design: Hugh Zimmern, Leigh & Orange

2/F, Club Lusitano Building, Duddell Street | Hong Kong | Central
Phone: +852 2526 5387
www.bloomsbury.com.hk
MTR: Central
Opening hours: Mon–Fri 9 am to 7 pm, Sat 9 am to 6 pm
Products: Professional business and reference titles
Special features: Self-service electronic book searching facilities, comfortable reading areas, free coffee

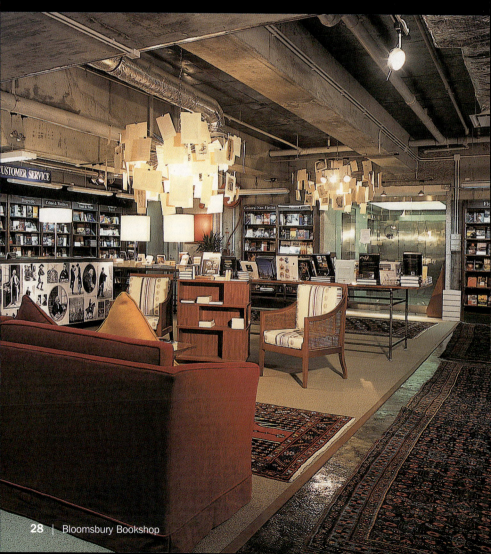

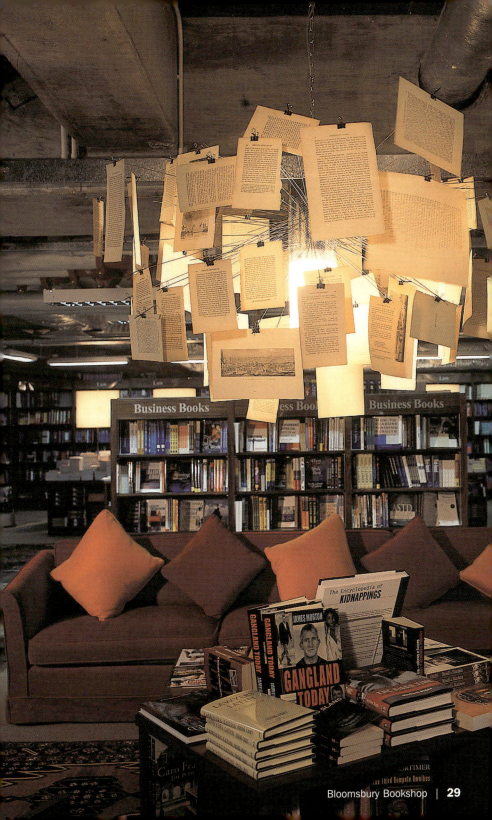

Biography Biography

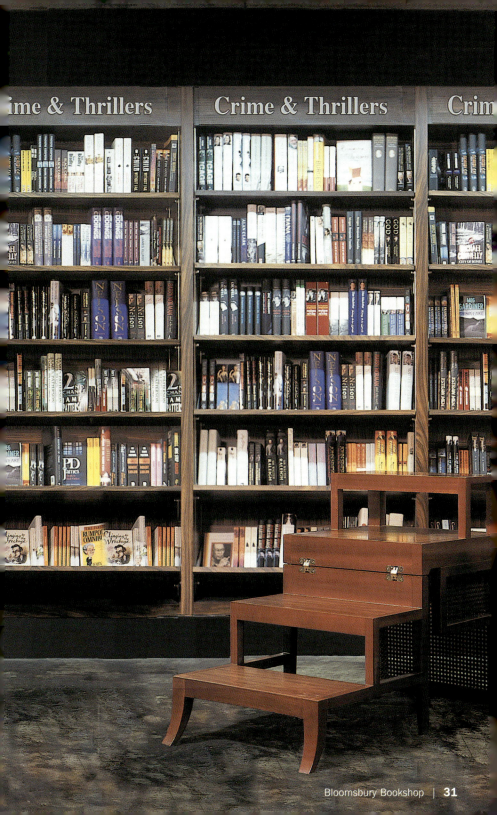

49 Staunton Street | Hong Kong | Central
Phone: +852 2540 3101
www.dialoguemen.com
MTR: Central
Opening hours: Every day noon to 10 pm
Products: Menswear for all occasions, bags and accessories
Special features: Feel like walking into a single man's home office, wine bar

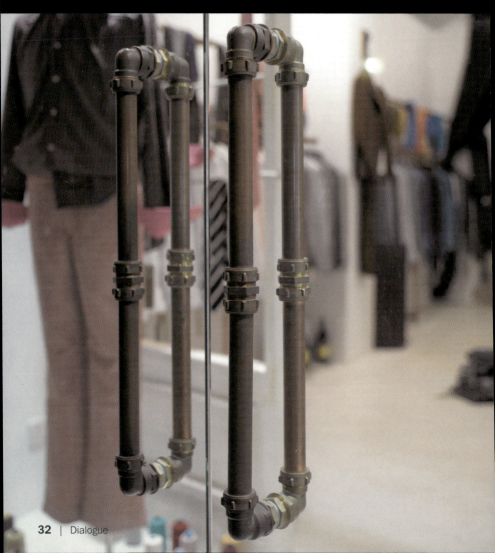

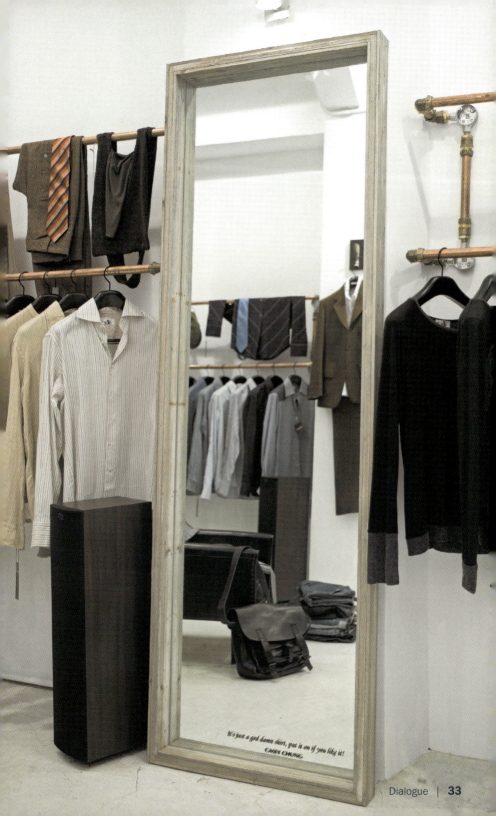

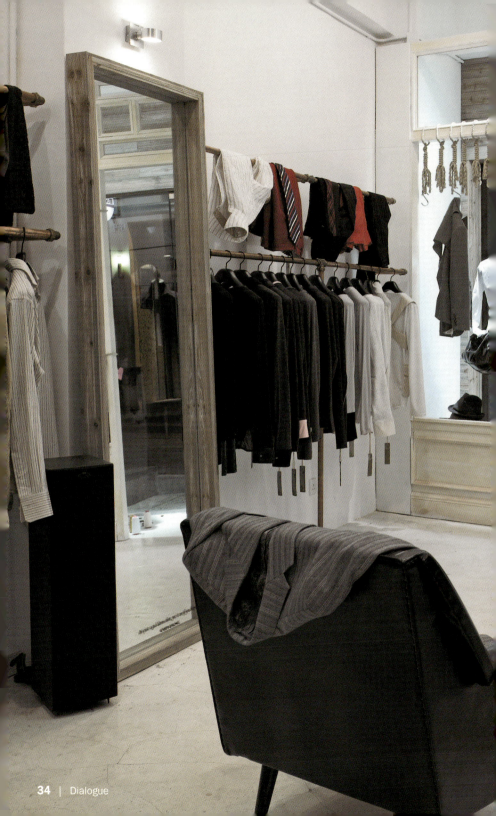

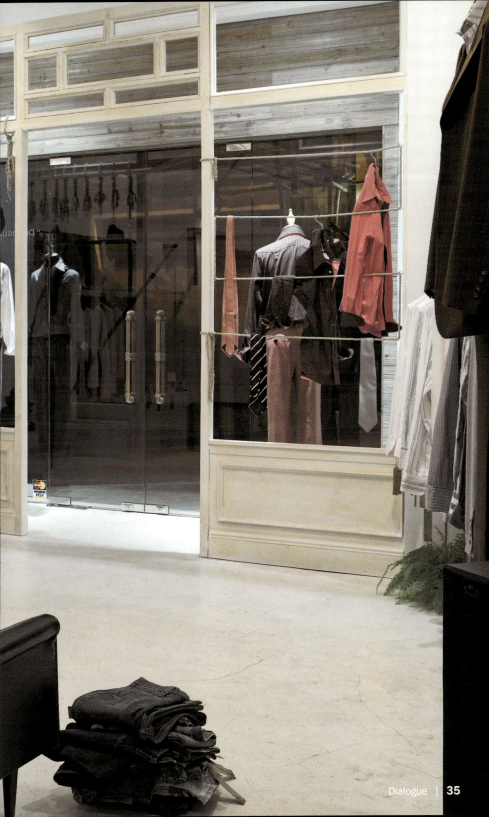

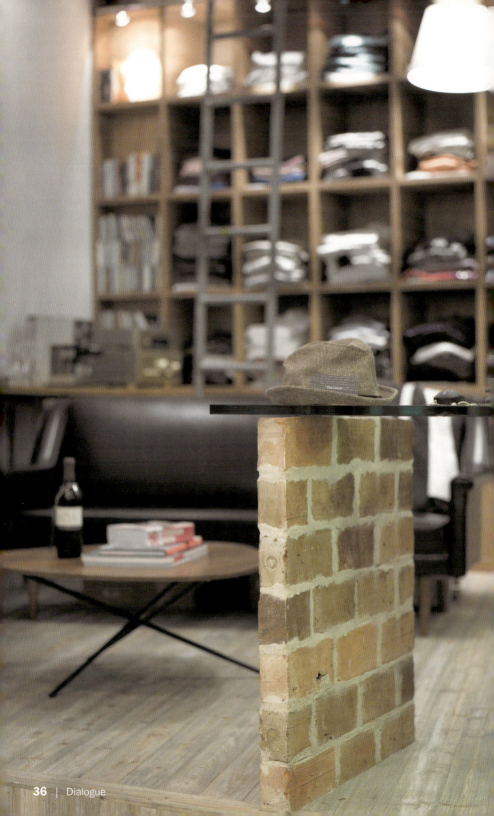

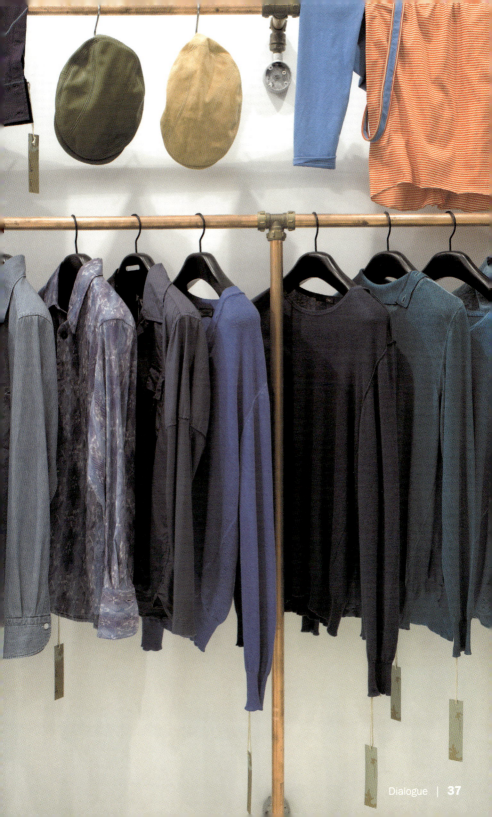

Emphasis Jewellery

Design: Antony Chan

41 Queen's Road | Hong Kong | Central
Phone: +852 2757 3726
www.emphasis.com
MTR: Central
Opening hours: Every day 10 am to 8 pm
Products: Fine jewelry
Special features: Mezzanine VIP lounge

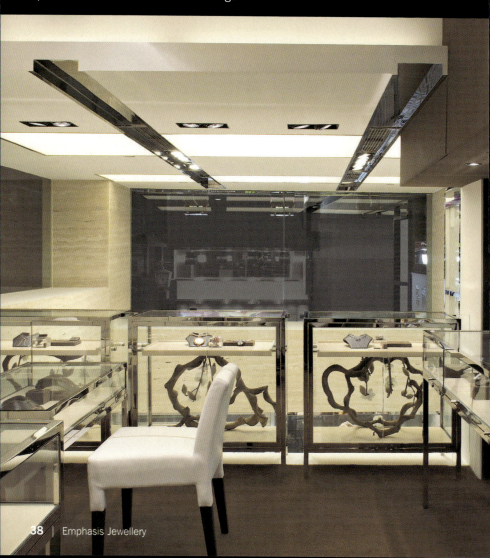

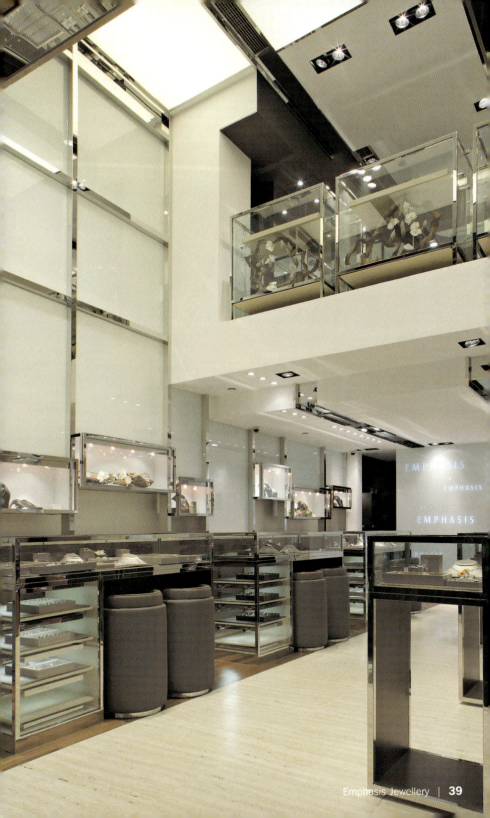

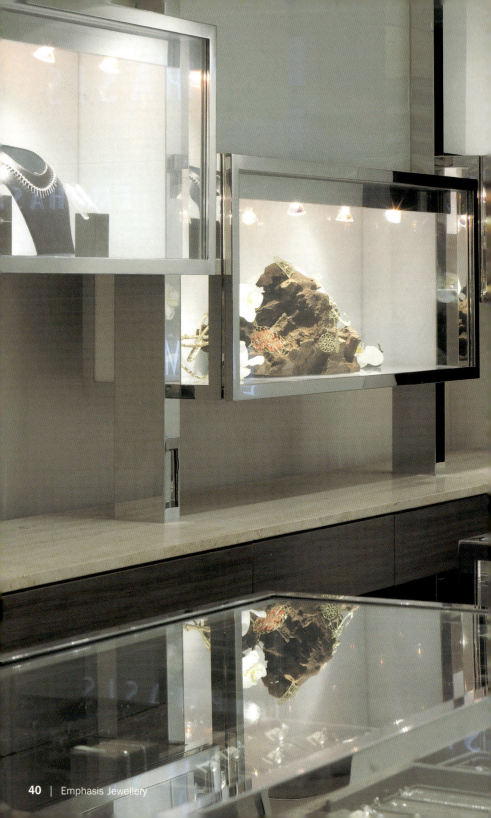

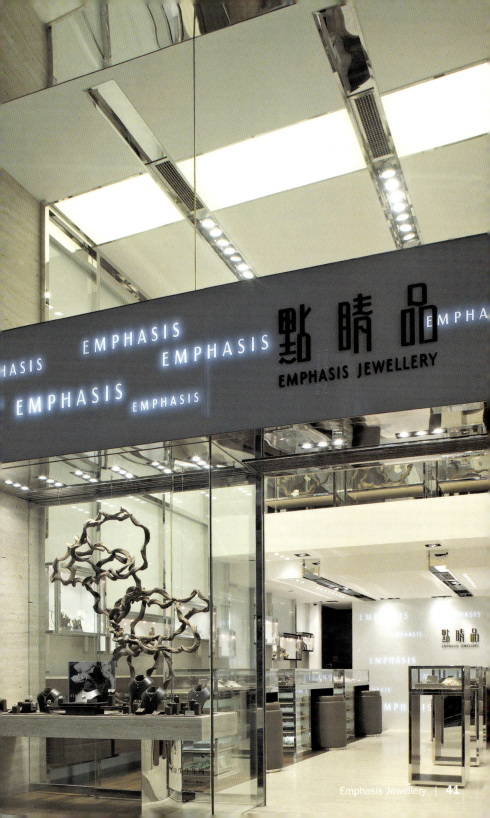

Emporio Armani
Chater House

Design: Doriana O. Mandrelli, Massimiliano Fuksas

11 Chater Road | Hong Kong | Central
Phone: +852 2532 7777
www.giorgioarmani.com.hk
MTR: Central
Opening hours: Mon–Sat 10:30 am to 7:30 pm, Sun 11 am to 7:30 pm
Products: Clothes, accessories for men and women
Special features: Restaurant included, cosmetics

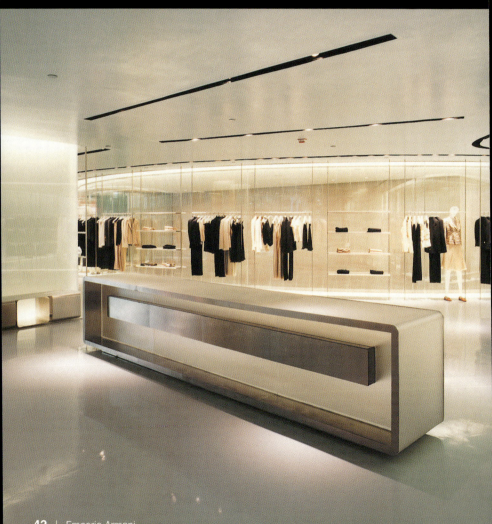

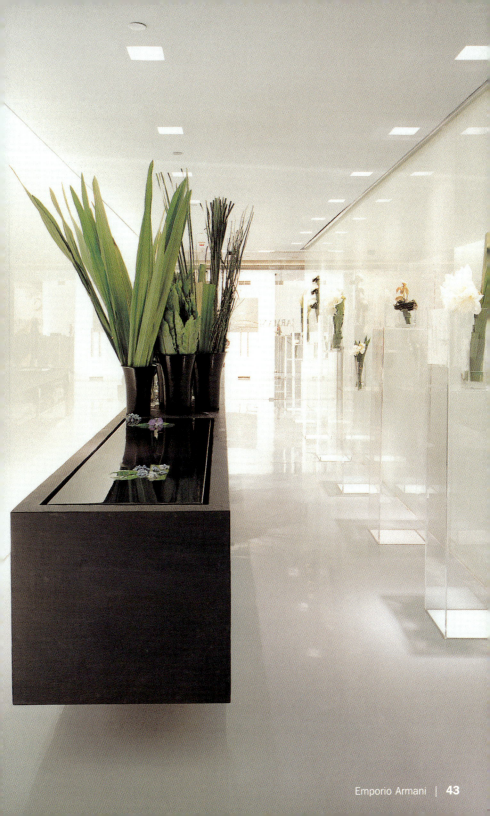

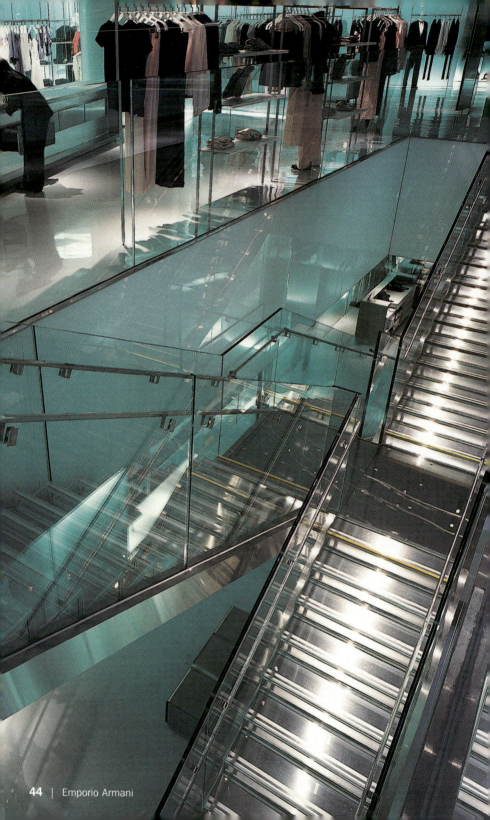

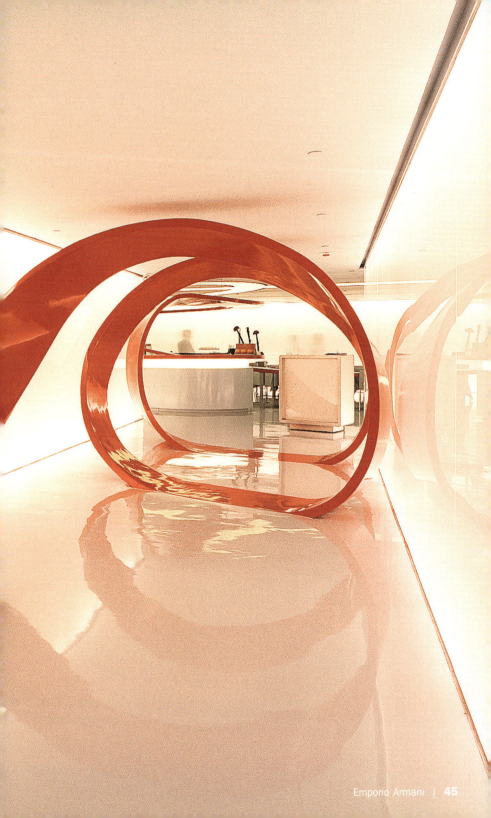

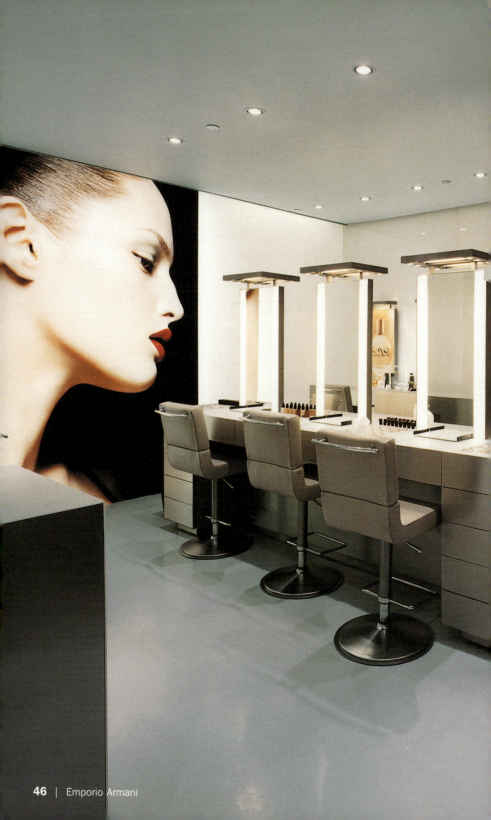

GIORGIO ARMANI
cosmetics

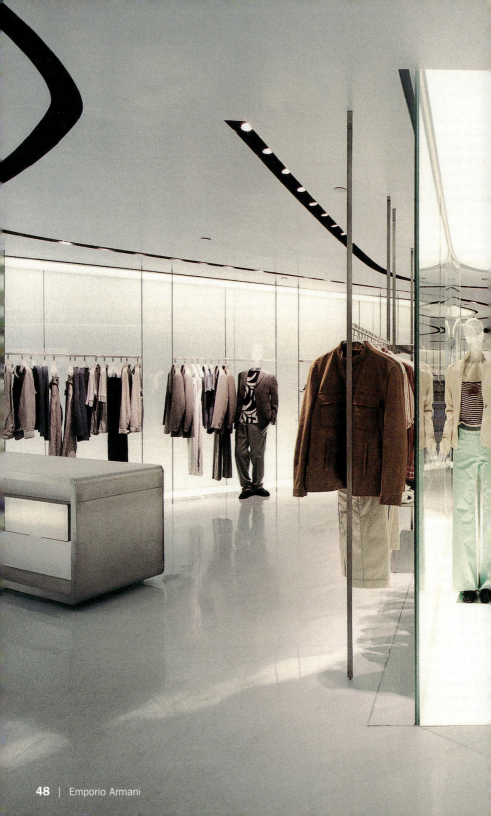

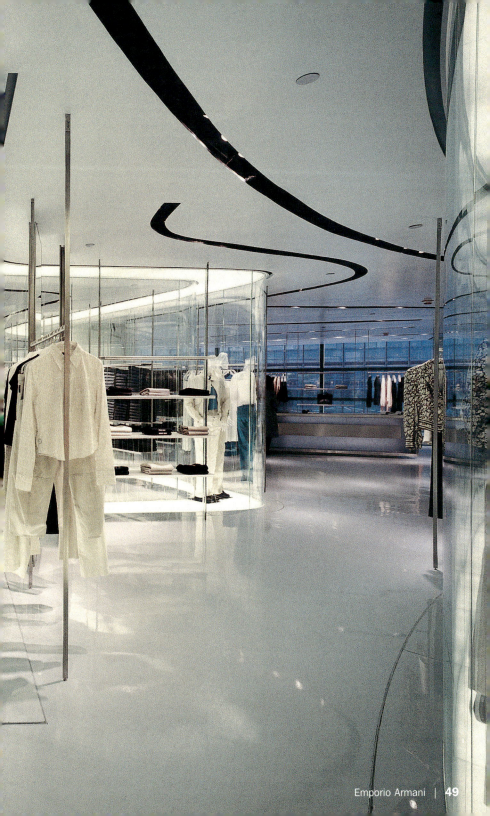

Eu Yan Sang

Design: Joseph Sy, Joseph Sy & Associates

Shop 302-303, Telford Gardens Plaza II, 33 Wai Yip Street | Hong Kong | Kowloon Bay
Phone: +852 2997 2268
www.euyansang.com.sg
MTR: Kowloon Bay
Opening hours: Every day 10 am to 9 pm
Products: Pharmacy, healthcare products, traditional Chinese medicines and herbs
Special features: Showcase explaining benefits of certain medicines

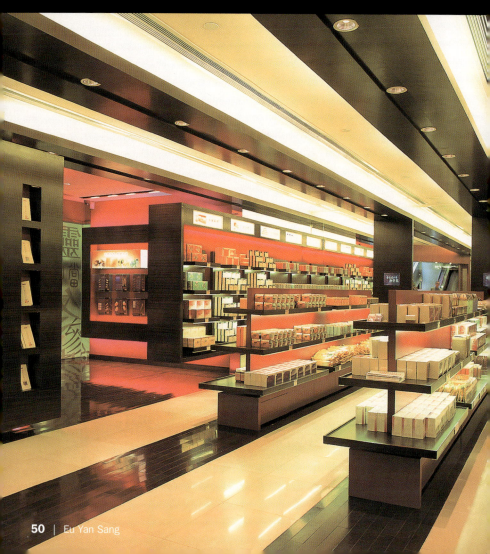

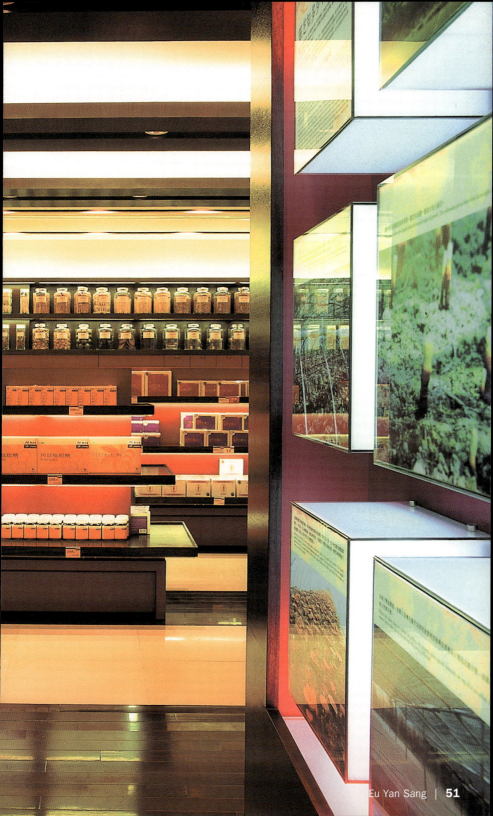

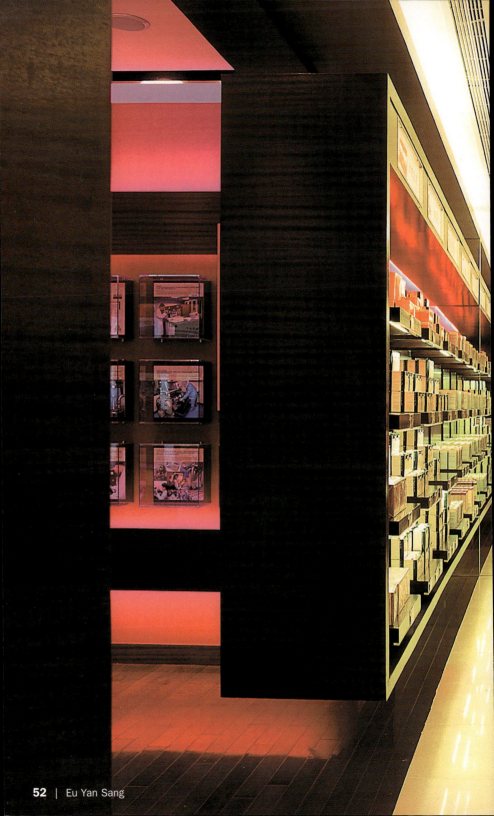

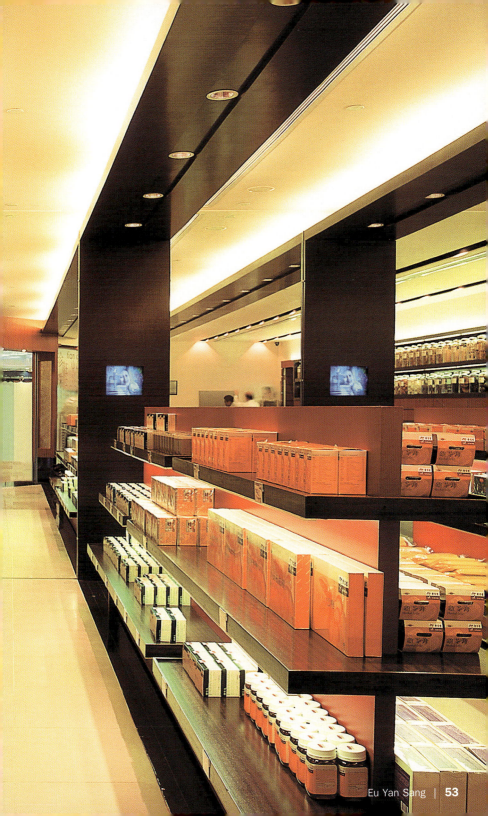

Evisu
ifc mall

Design: Semeiotics, Design Systems

Shop 3097, ifc mall, Finance Street | Hong Kong | Central
Phone: +852 2234 7266
www.evisu.com
MTR: Central
Opening hours: Every day 11:30 am to 8 pm
Products: Clothing

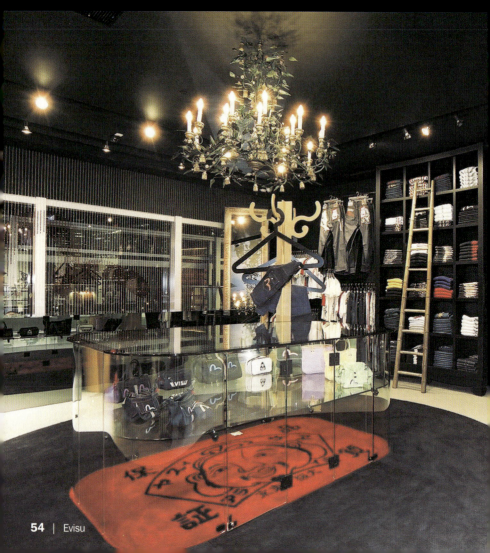

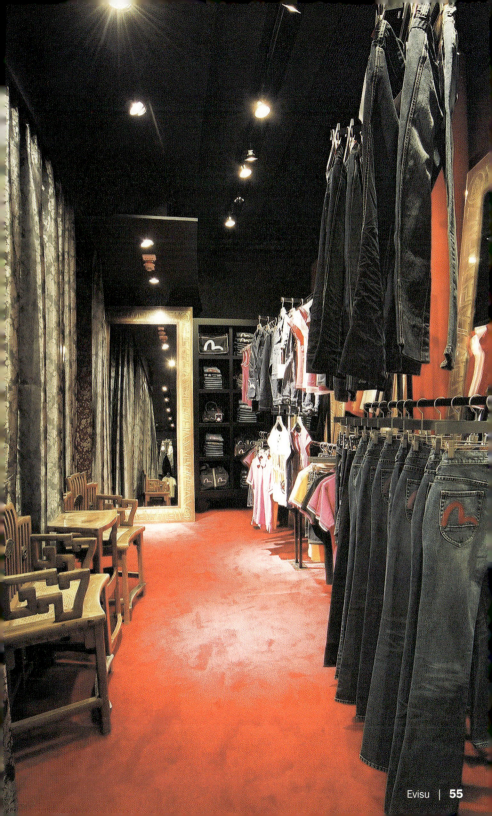

Galerie Vee

Design: Building Design Studio

2/F, Shop 225, Prince's Building | Hong Kong | Central
Phone: +852 2522 3166
www.galerievee.com
MTR: Central
Opening hours: Mon–Sat 10 am to 7 pm
Products: Studio glass art and ceramics
Special features: Museum sculptures included, studio work by important contemporary glass and ceramic artists

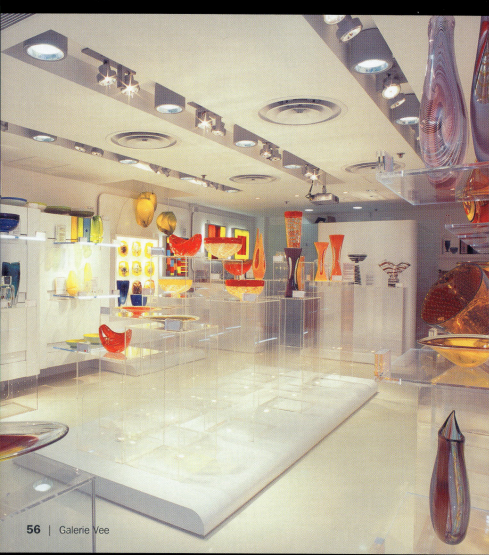

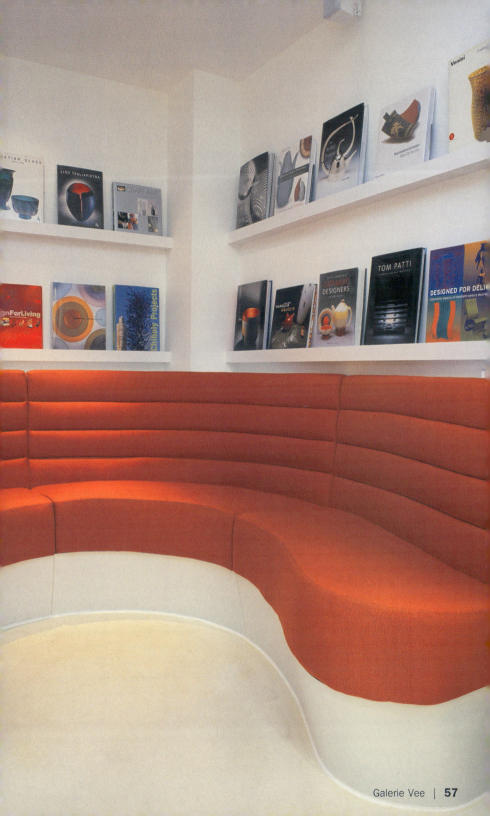

GOD

Design: Atelier Pacific

Leighton Centre, East Entrance, Sharp Street | Hong Kong | Causeway Bay
Phone: +852 2890 5555
www.god.com.hk
MTR: Causeway Bay
Opening hours: Every day noon to 11 pm
Products: Furniture and homeware
Special features: Dedicated restaurant and flower shop located adjacent

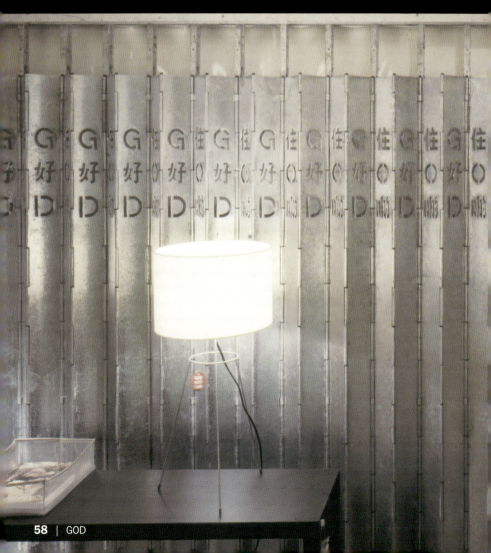

住好啲

Graham 32

Design: Atelier Pacific

32 Graham Street | Hong Kong | Central
Phone: +852 2815 5188
www.graham32.com
MTR: Central
Opening hours: Mon–Sat 11 am to 7 pm
Products: Flowers, art and unique life-style accessories
Special features: Voted as one of the top 100 Cool New Places by Conde-Nast Traveller

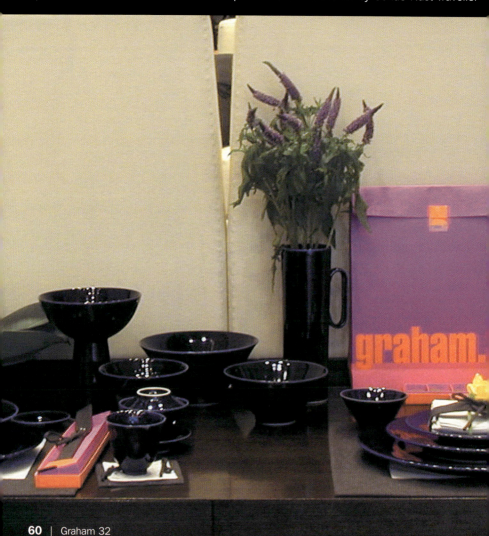

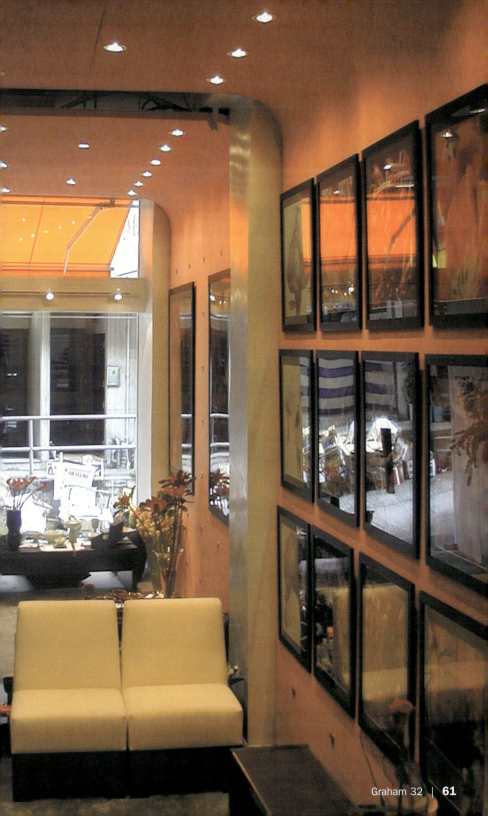

Habitus

Design: Tsang Tak-ping

3/F, Western Market, 323 Des Vouex Road Central | Hong Kong | Sheung Wan
Phone: +852 2973 0231
www.habitus.com.hk
MTR: Sheung Wan
Opening hours: Sun–Wed 10 am to 7 pm, Thu–Sat 10 am to 1 am
Products: Contemporary art and design
Special features: Cultural events such as art and design exhibitions, poetry reading, video screening and live music

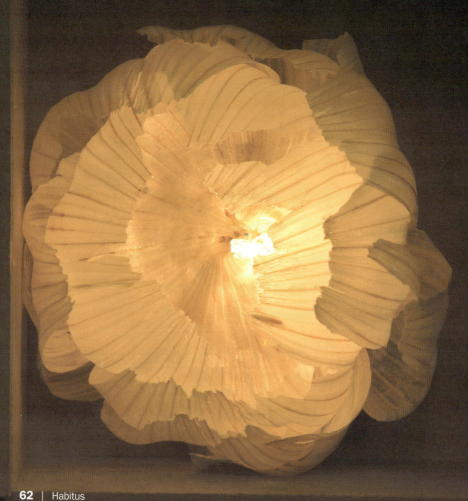

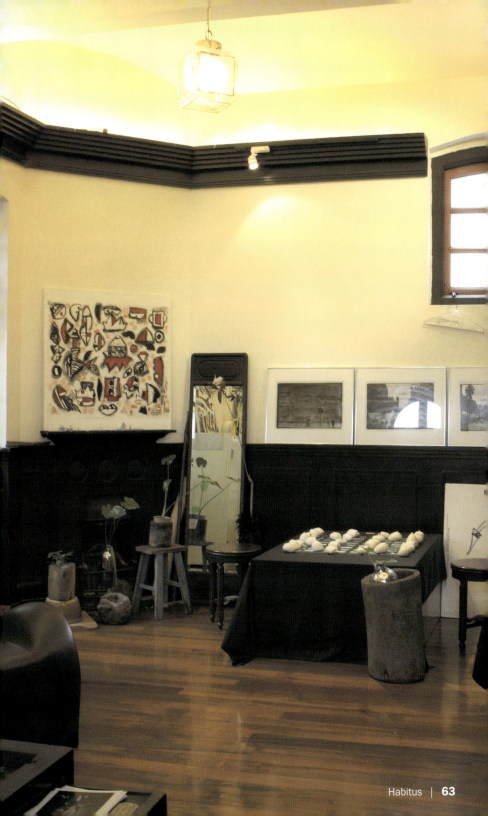

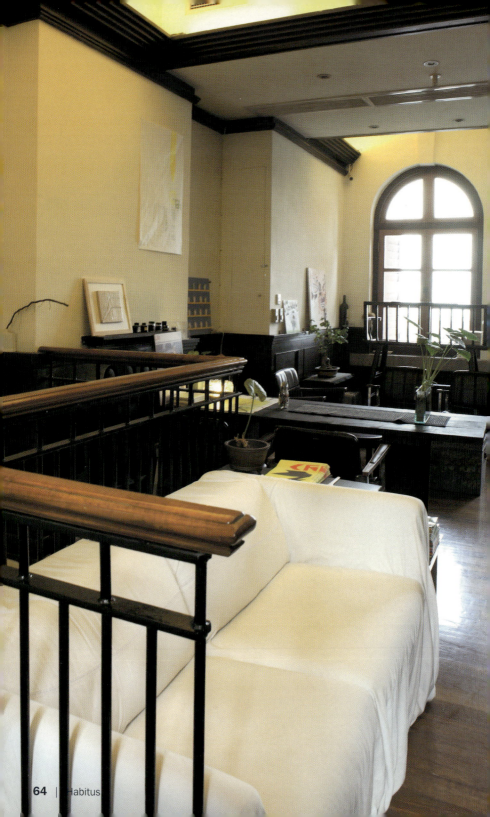

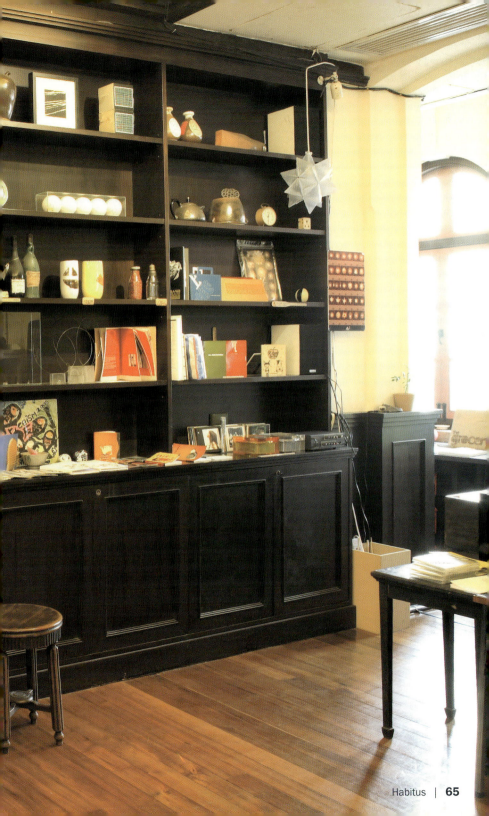

Harvey Nichols Store

Design: Christian Biecher and Associates

The Landmark, 15 Queen's Road Central | Hong Kong | Central
Phone: +852 3695 3388
www.harveynichols.com
MTR: Central
Opening hours: Mon–Sat 10 am to 9 pm, Sun 10 am to 7 pm
Products: Luxury fashion and accessories brands
Special features: Personal shopping, The Fourth Floor restaurant & bar

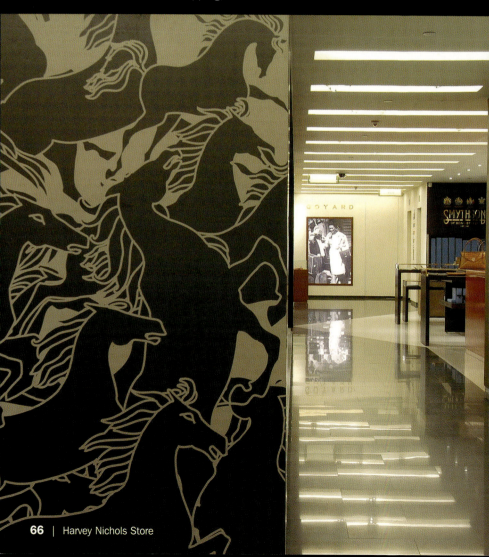

Harvey Nichols Store

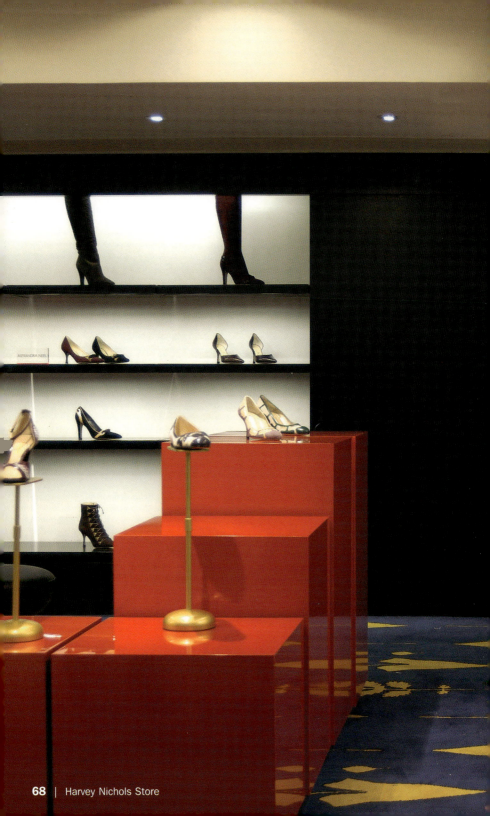

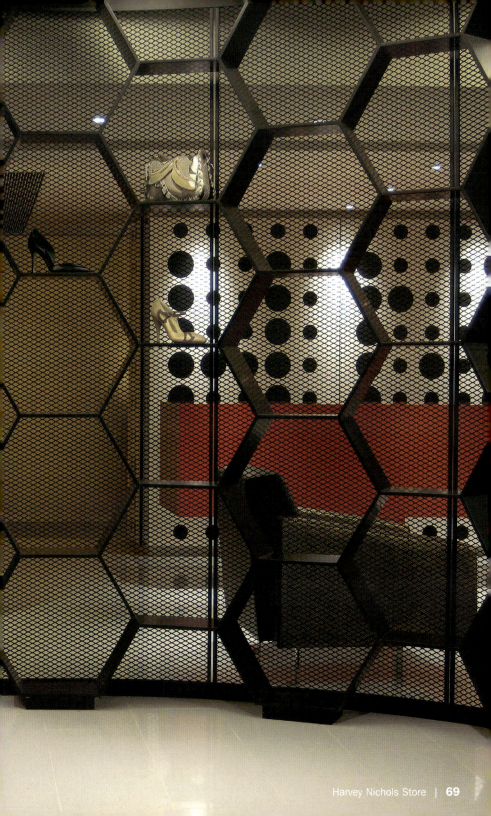

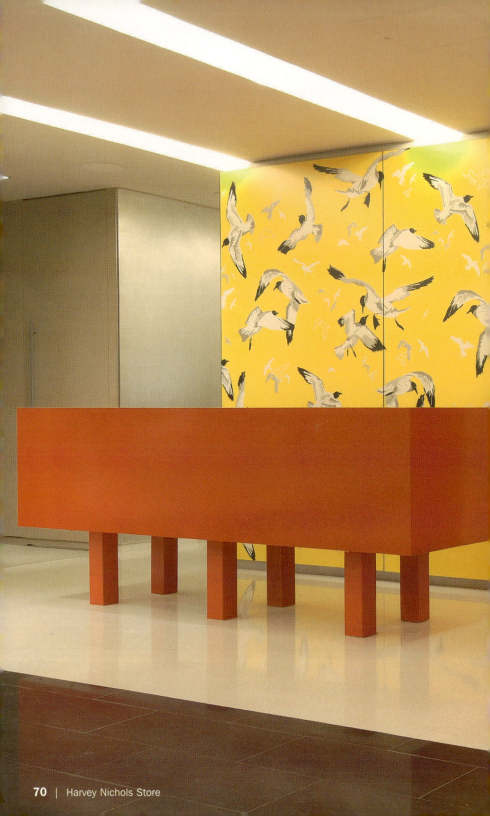

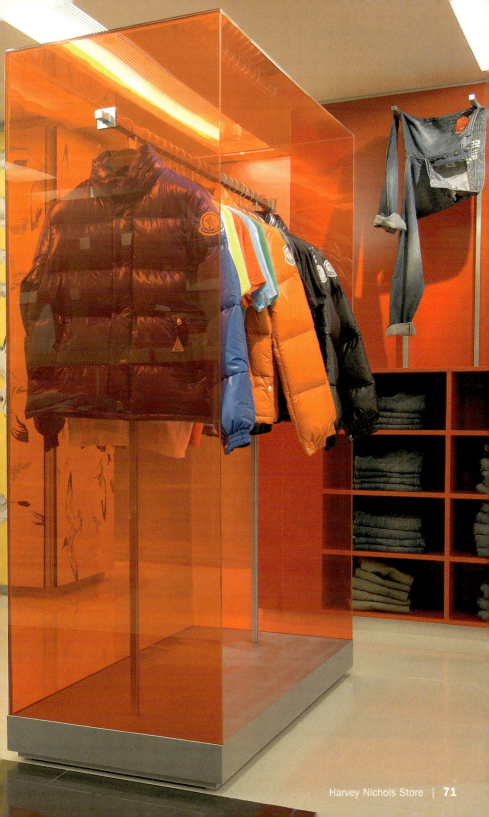

I.T Pacific Place

Design: Masamichi Katayama

G/F, Pacific Place | Hong Kong | Wanchai
Phone: +852 2918 9522
www.ithk.com
MTR: Admiralty
Opening hours: Every day noon to 9 pm
Products: Designer women and men's collection

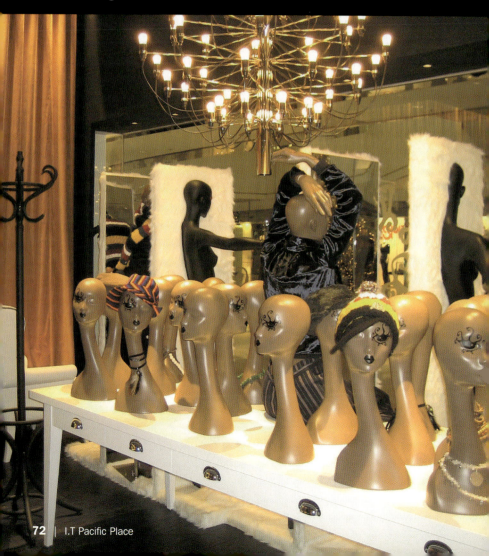

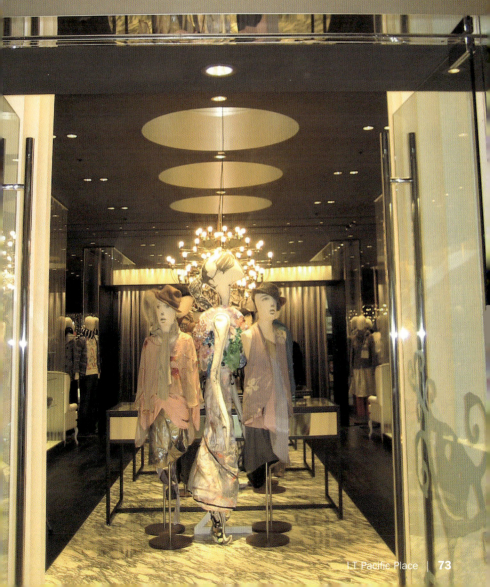

I.T Pacific Place

Joyce

Design: Gert Voorjans, Michele Oka Doner

New World Tower, Queen's Road Central | Hong Kong | Central
Phone: +852 2810 1120
MTR: Central
Opening hours: Mon–Sat 10:30 am to 7:30 pm, Sun and public holidays 11 am to 7 pm
Products: Designer women and men's collection

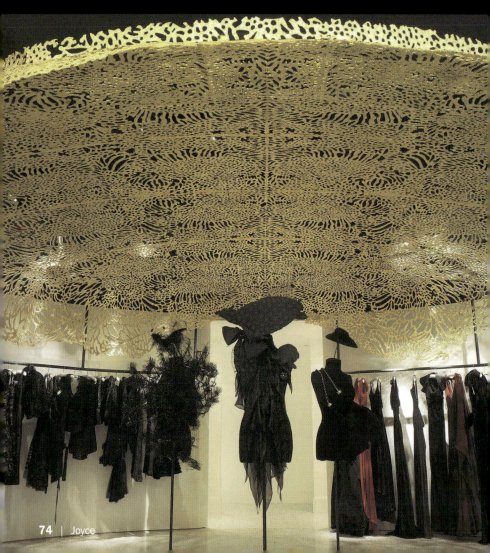

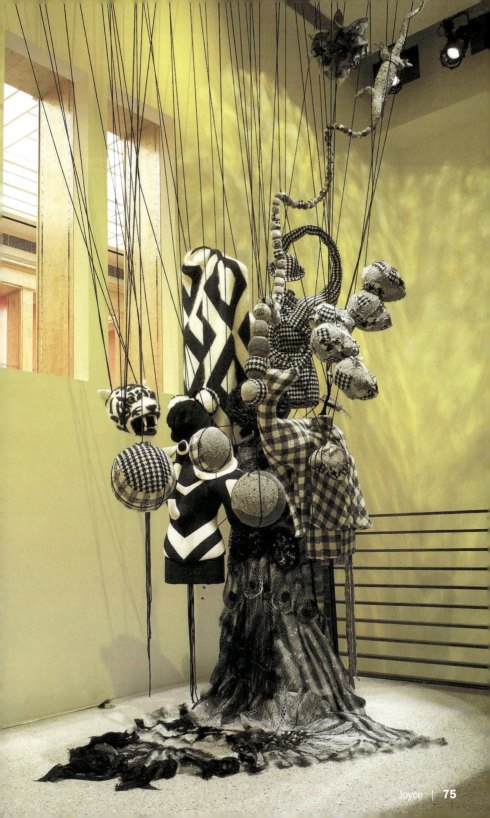

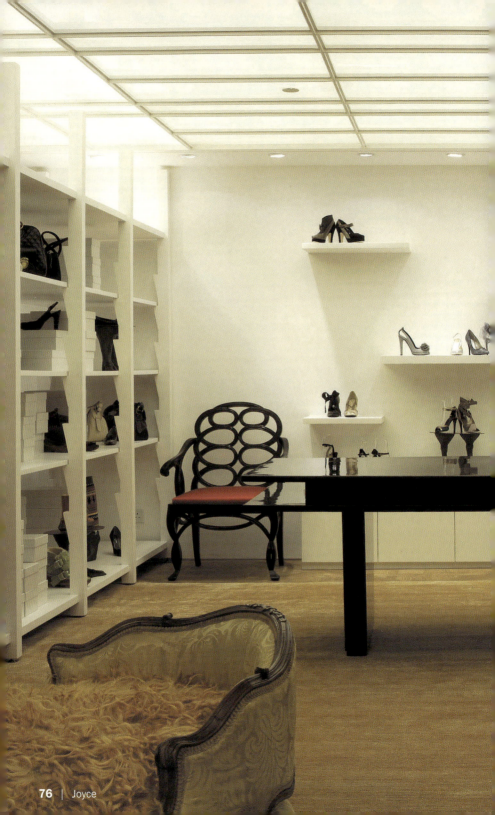

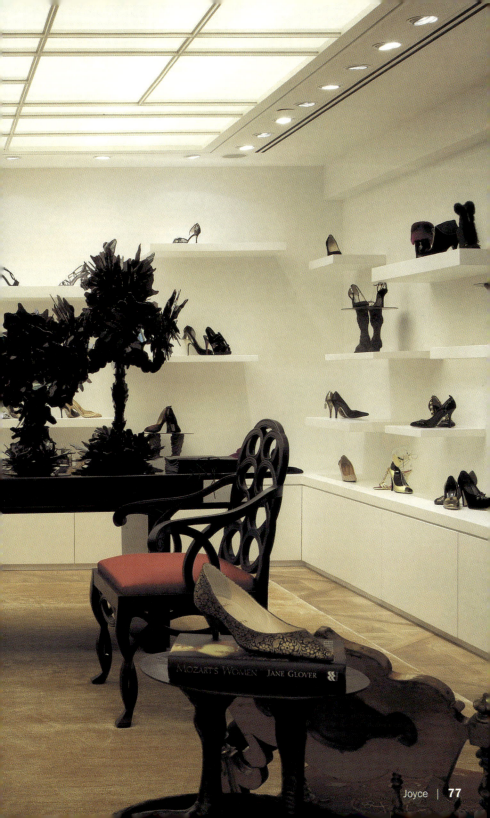

KOU

Design: Lu Kou

22/Fung House, 20 Connaught Road | Hong Kong | Central
Phone: +852 2530 2234
www.kouconcept.com
MTR: Central
Opening hours: Mon–Sat 11 am to 9 pm, Sun open during Dec 11 am to 9 pm, public holiday 2 pm to 7 pm
Products: Any decorative item for at home, interior design, home accessorizing, wedding gift registry
Special features: Hand picked accessories by Lu Kou from Europe and all over the world

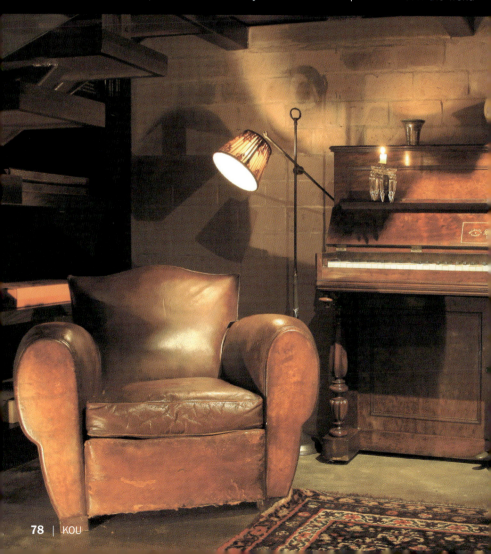

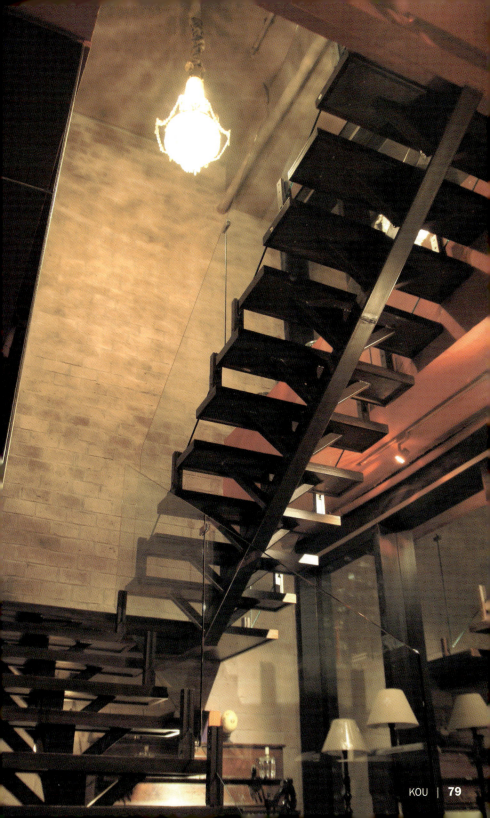

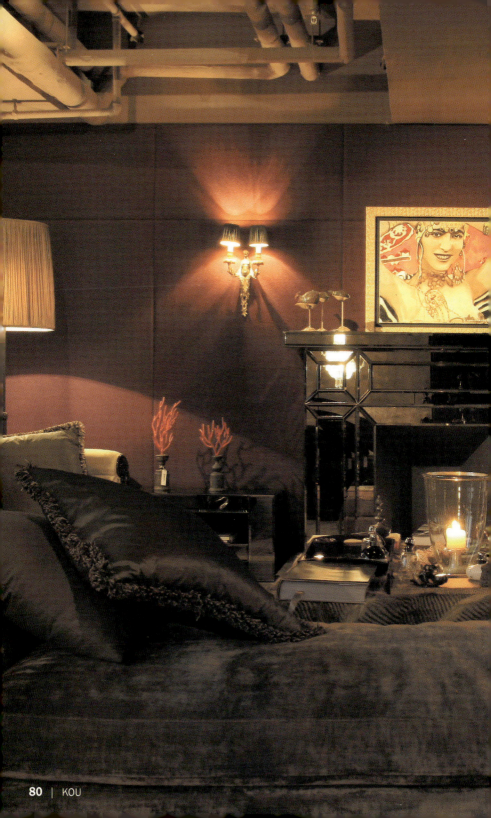

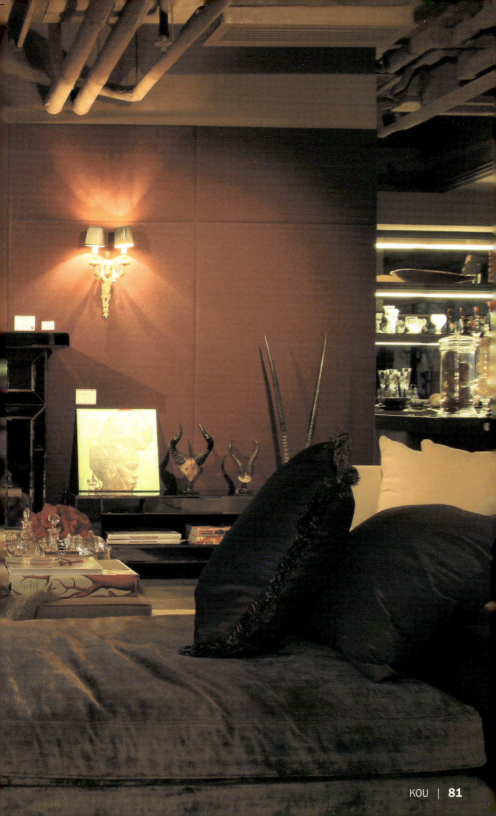

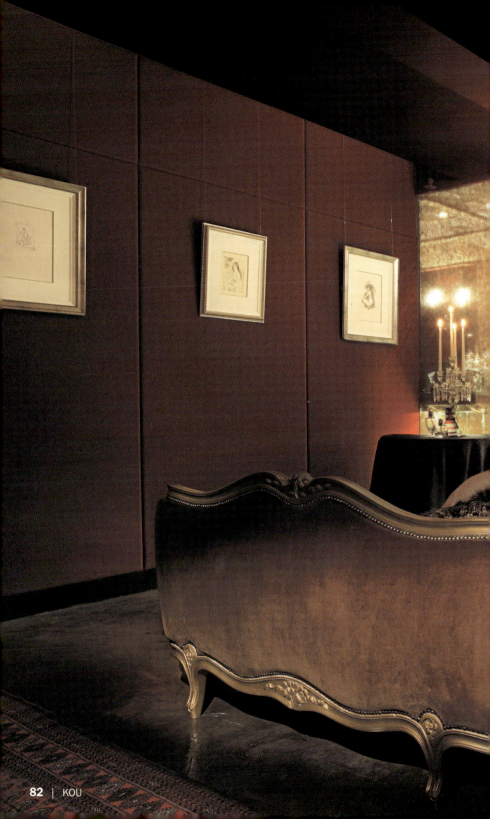

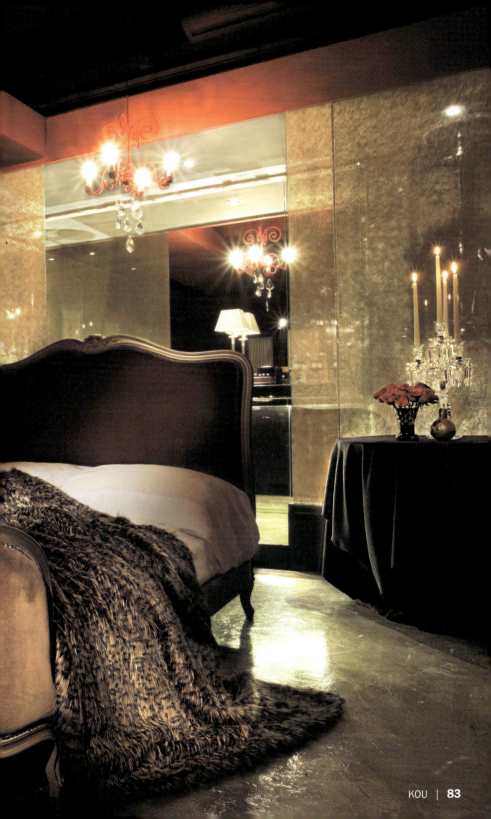

Lane Crawford
ifc mall

Design: George Yabu & Glenn Pushelberg

Podium 3, ifc mall, 8 Finance Street | Hong Kong | Central
Phone: +852 2118 2888
www.lanecrawford.com
MTR: Central
Opening hours: Every day 10 am to 9 pm
Products: Designer's fashion collections for men and women, jewelry, lingerie, home furnishing, shoes and accessories, cosmetics and fragrances

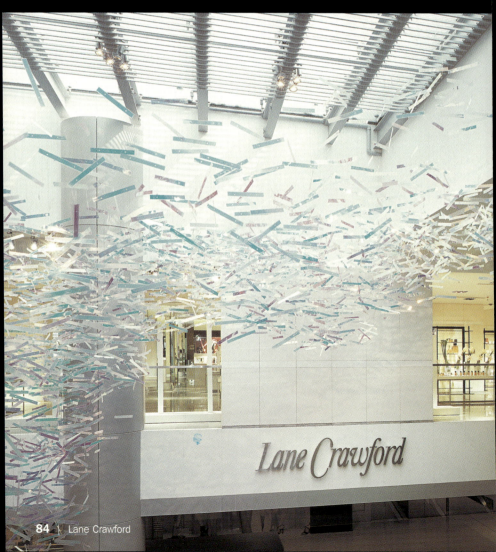

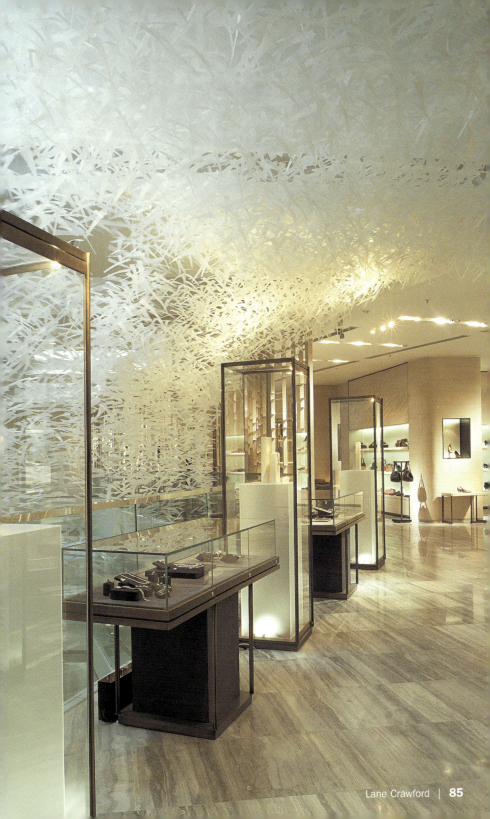

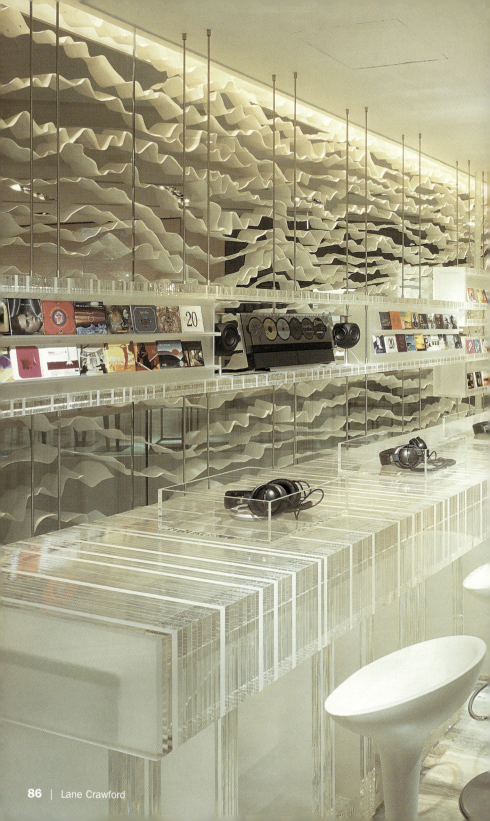

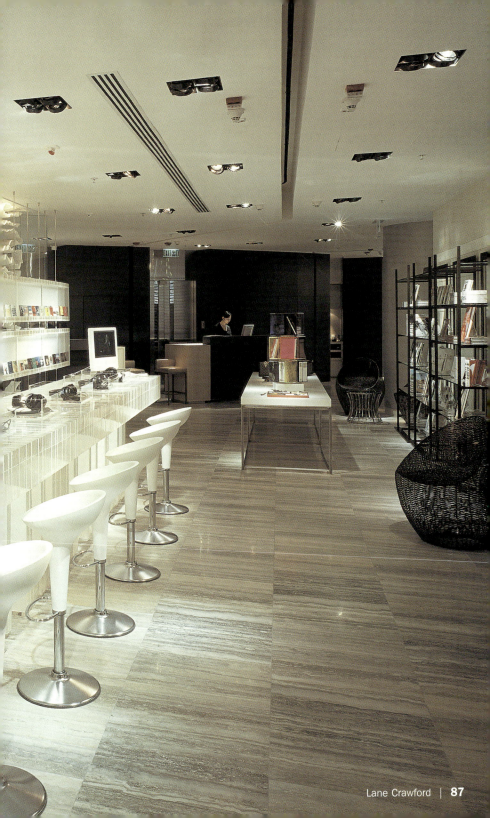

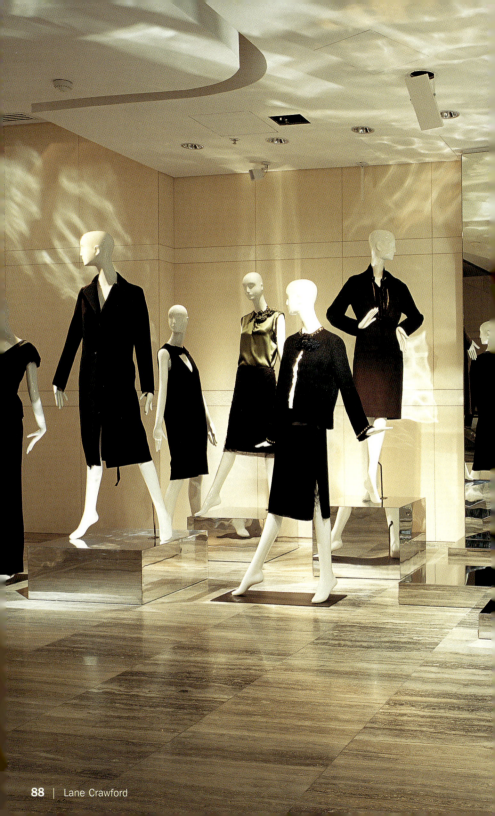

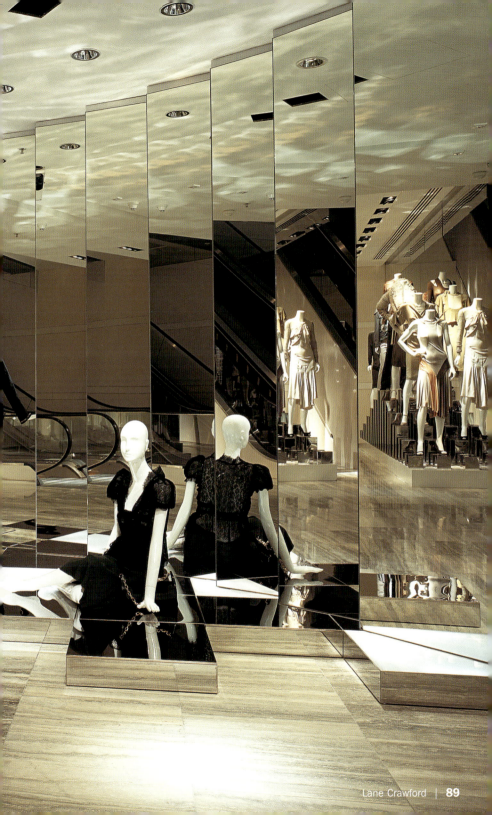

Libre!

Design: Antony Chan

1/F, G/F, Emperoland Comm. Building, 2-4 On Lan Street | Hong Kong | Central
Phone: +852 2523 6880
www.libre.com.hk
MTR: Central
Opening hours: Every day 11 am to 8 pm
Products: Fashion, shoes, bags and accessories

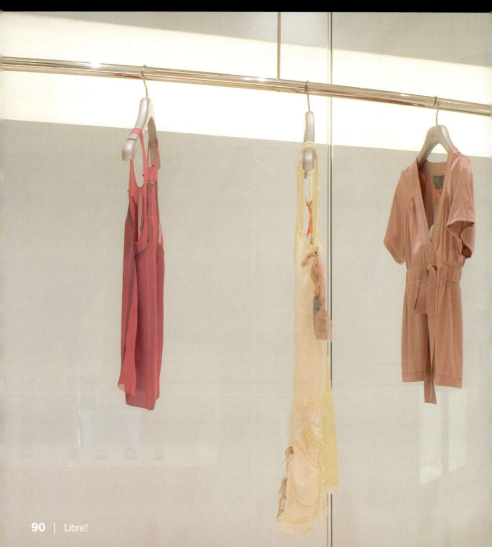

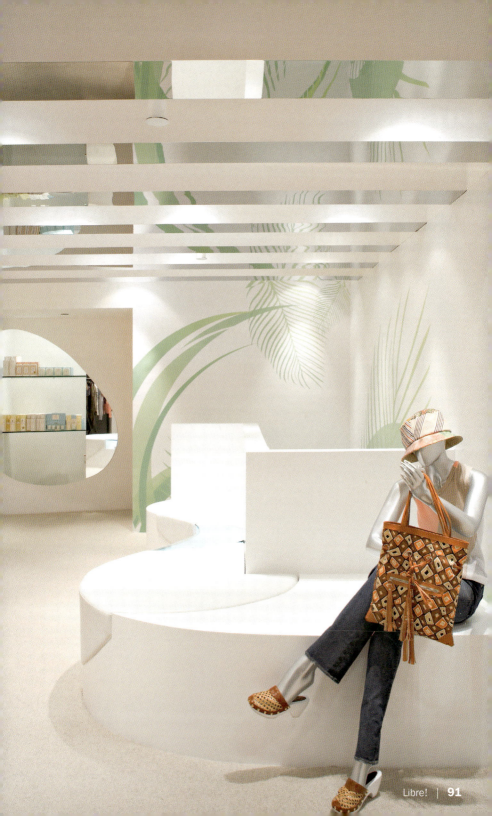

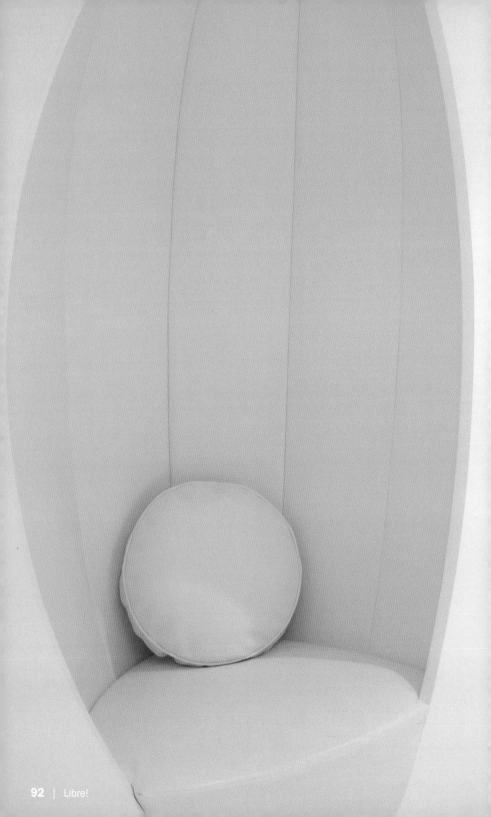

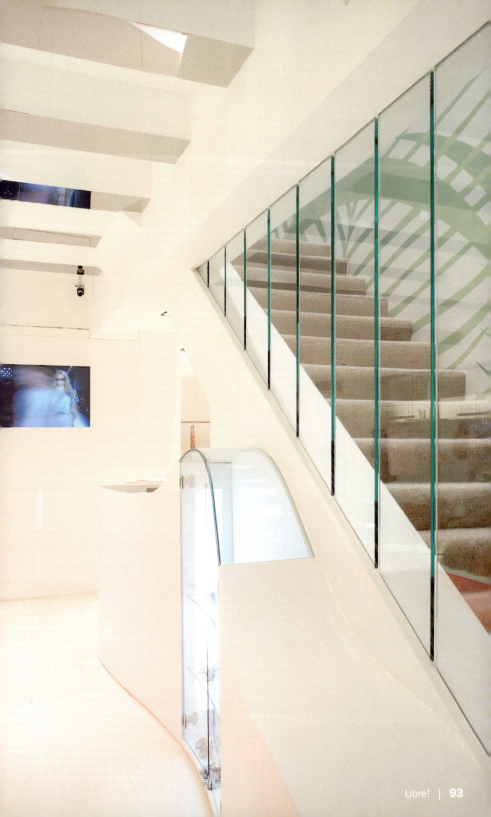

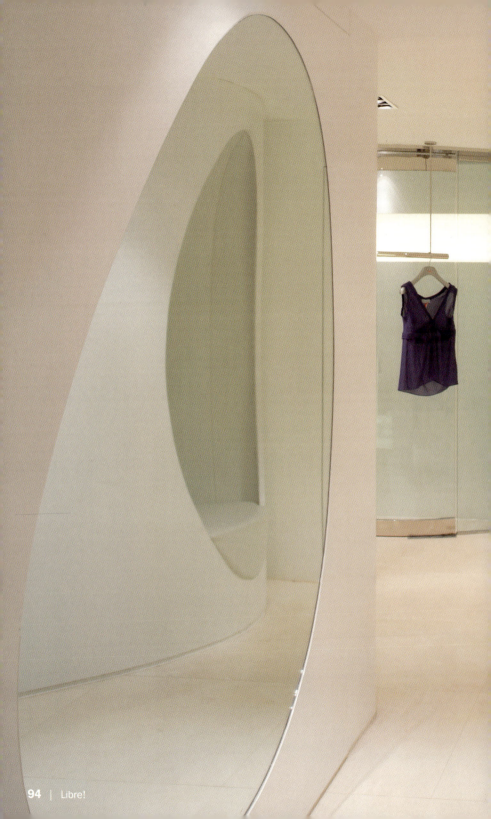

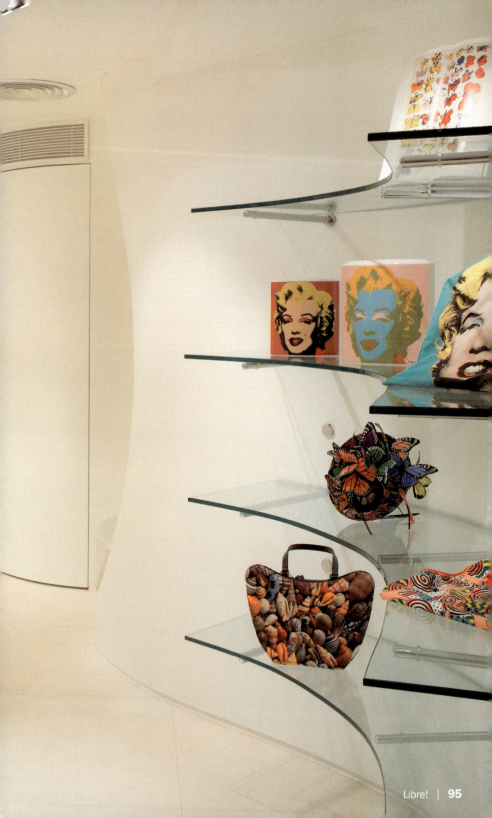

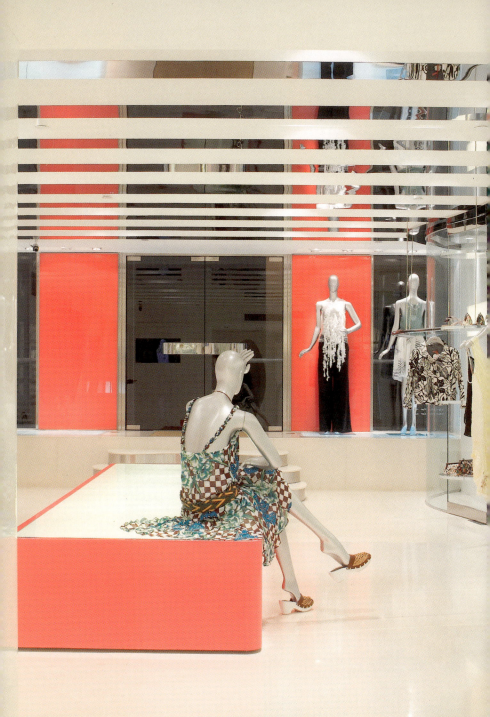

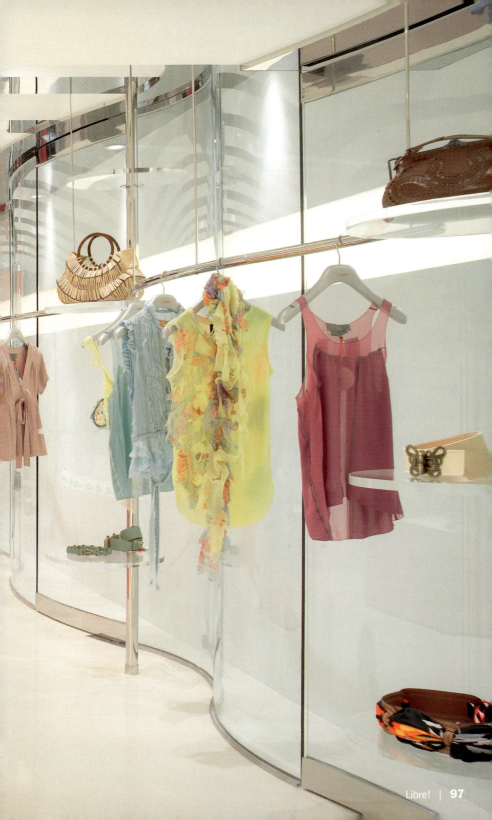

Shop G06-08, The Lee Garden, 33 Hysan Road | Hong Kong | Causeway Bay
Phone: +852 2736 6100
www.vuitton.com
MTR: Causeway Bay
Opening hours: Every day 10:30 am to 9 pm
Products: Leather goods, ready-to-wear and shoes
Special features: Over 24,000 LED's allow the internal and external façade to be constantly "shimmering" and "alive"

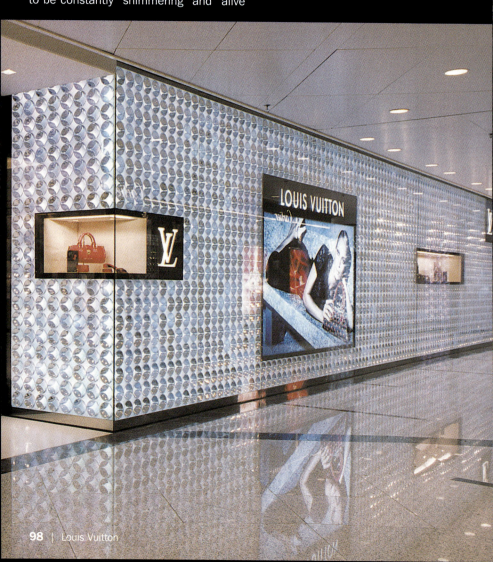

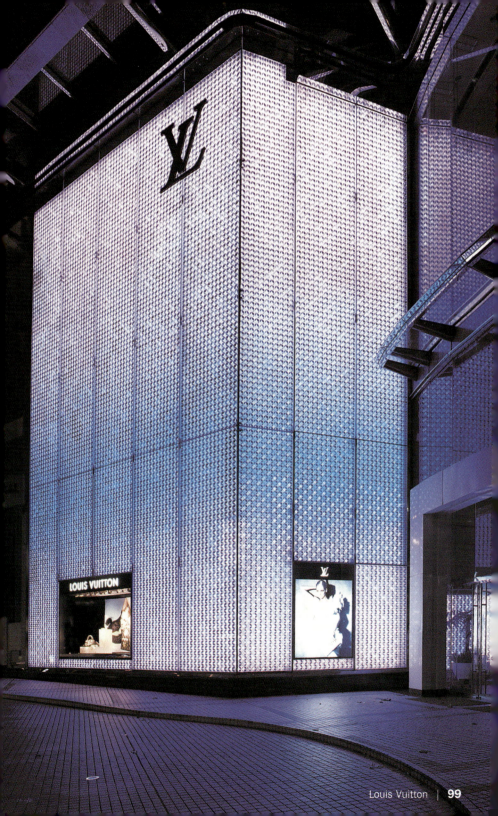

Louvre Gallery

Design: Carlo Columbo

Shop B, Lower Ground Floor, Ruttonjee Centre, 11 Duddell Street | Hong Kong | Central
Phone: +852 2526 8400
www.louvre.com.hk
MTR: Central
Opening hours: Mon-Sat 10 am to 7 pm, Sun and public holidays closed
Products: Top end European furniture, lighting and art pieces

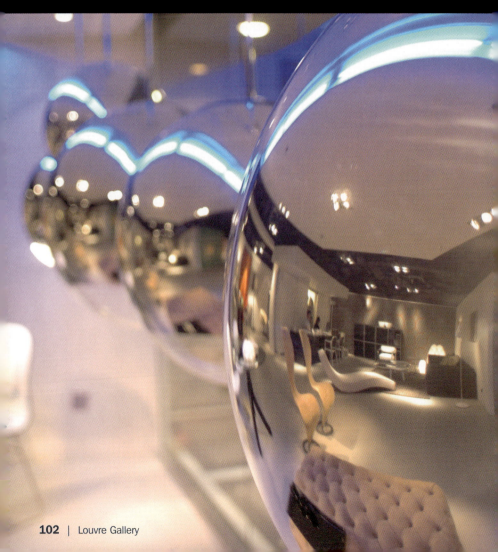

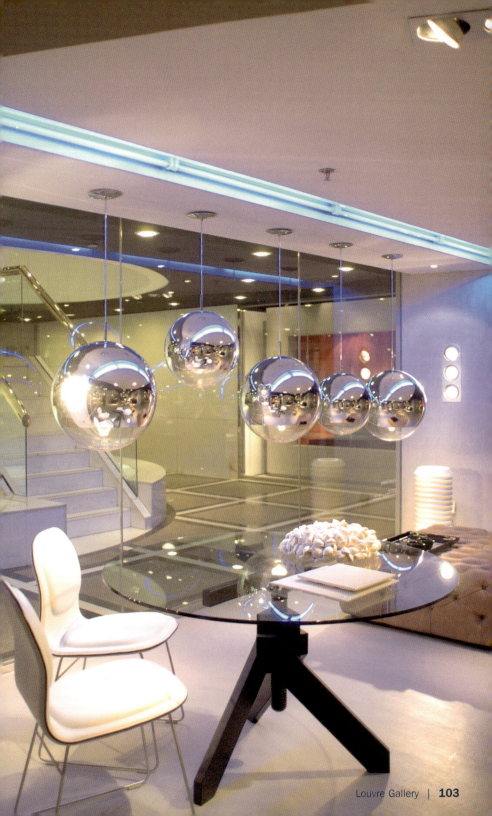

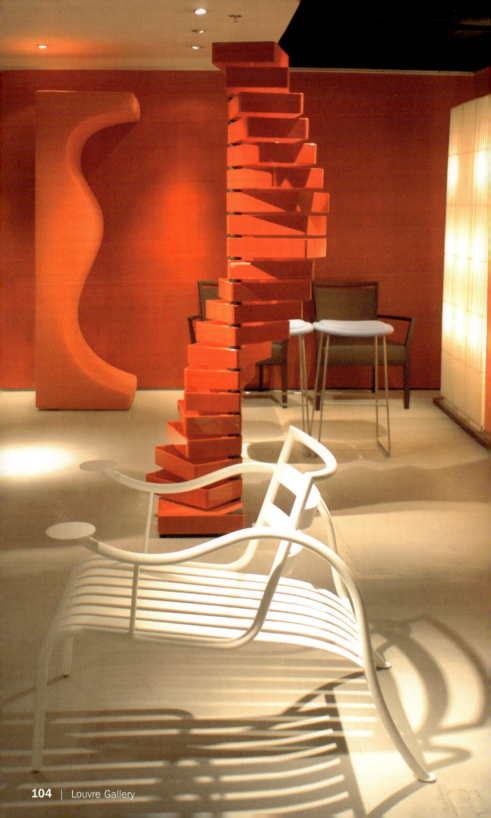

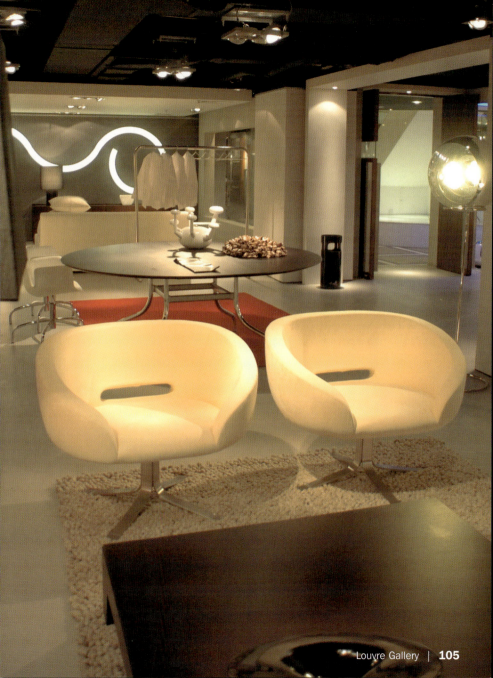

Maybach Centre
of Excellence

Design: KplusK associates, Johnny Kember

60 Repulse Bay Road | Hong Kong | Repulse Bay
Phone: +852 2594 8133
www.maybach-manufaktur.com
Opening hours: by private appointment only
Products: Luxury automobiles
Special features: Ultimate high-tech sales environment and showroom

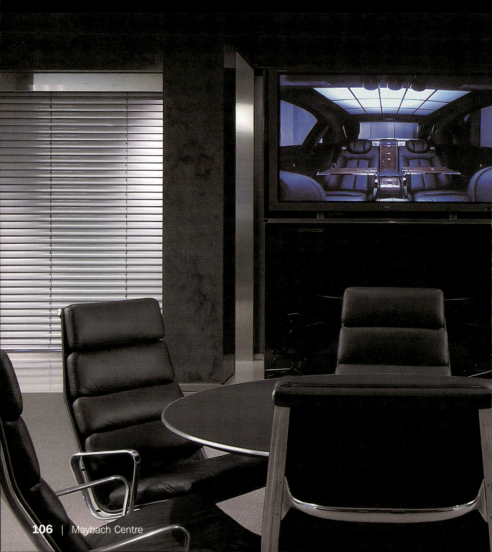

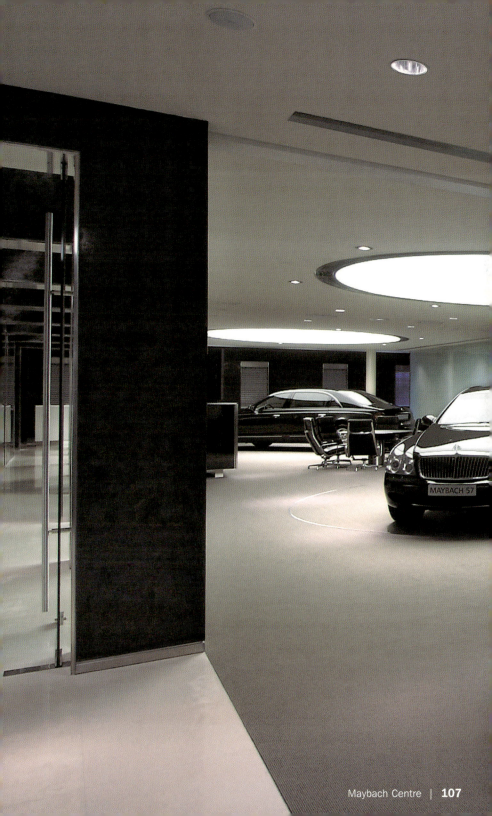

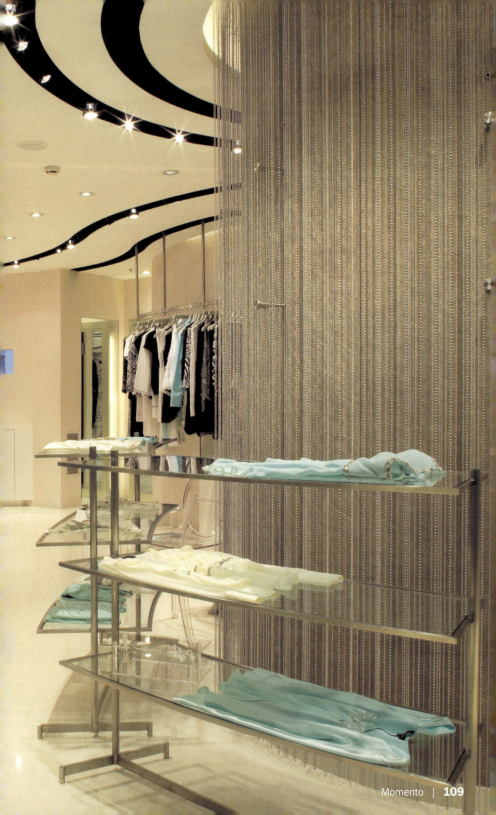

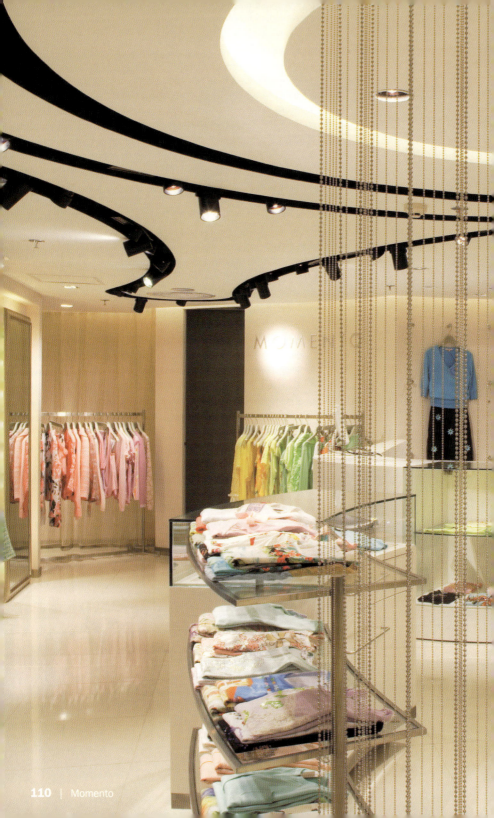

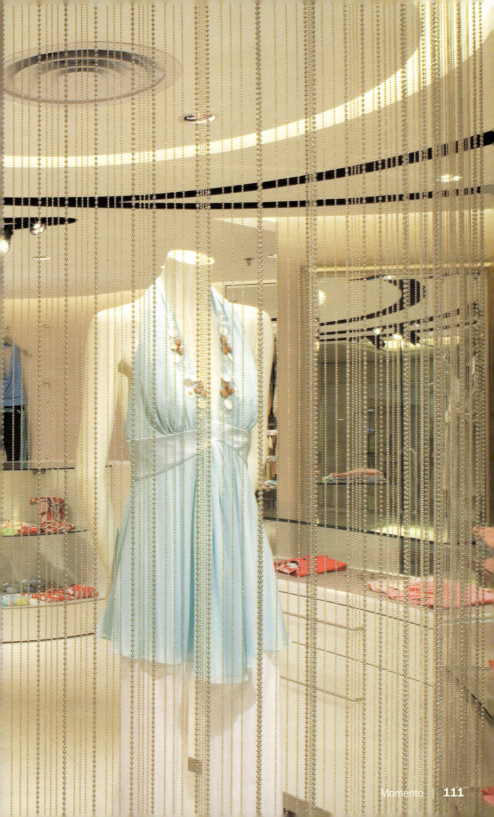

On Pedder

Design: Calvin Tsao

Unit C, G/F Wheelock House, 20 Pedder Street | Hong Kong | Central
Phone: +852 2118 3489
MTR: Central
Opening hours: Mon–Sat 11 am to 8 pm, Sun and public holidays 11 am to 7 pm
Products: Ladies' shoes, handbags and accessories
Special features: Private dressing room, shop privately during extended hours

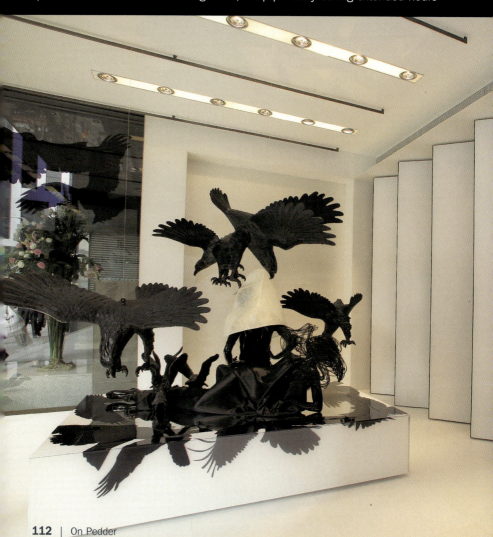

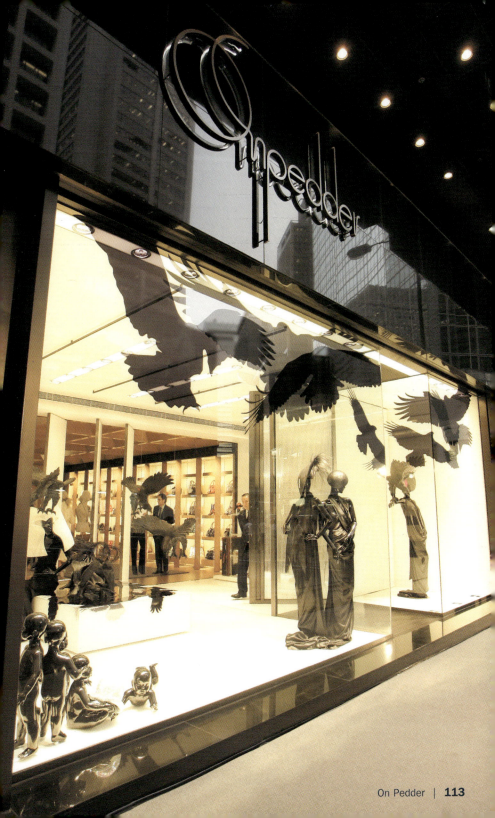

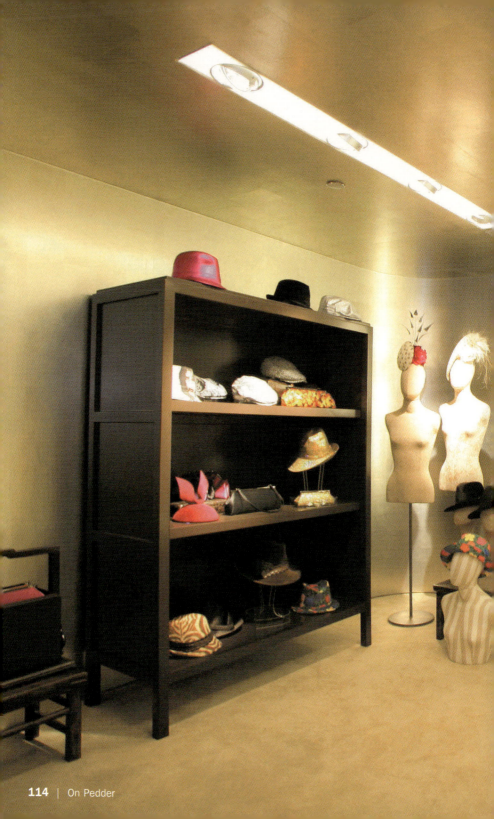

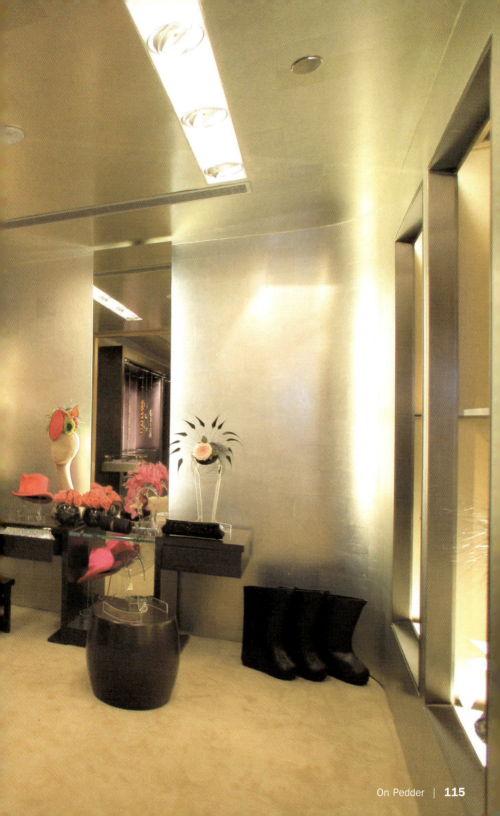

OVO Garden

Designer: Dan Lee, Calvin Ching, E.G.G design ltd

G/F, 16 Wing Fung Street | Hong Kong | Wanchai
Phone: +852 2529 2599
www.ovogarden.com.hk
MTR: Admiralty
Opening hours: Mon–Sat 9 am to 7 pm, Sun & public holidays closed
Products: Fresh flowers, floral arrangements, event decorations, monthly flowers
Special features: OVO specials shown special regards to balance, harmony, and form of floral arrangements

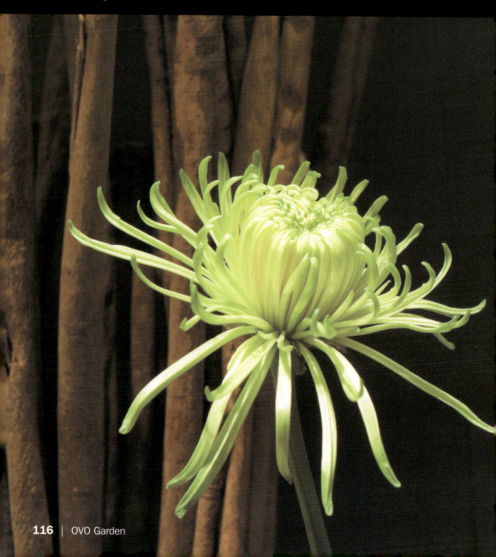

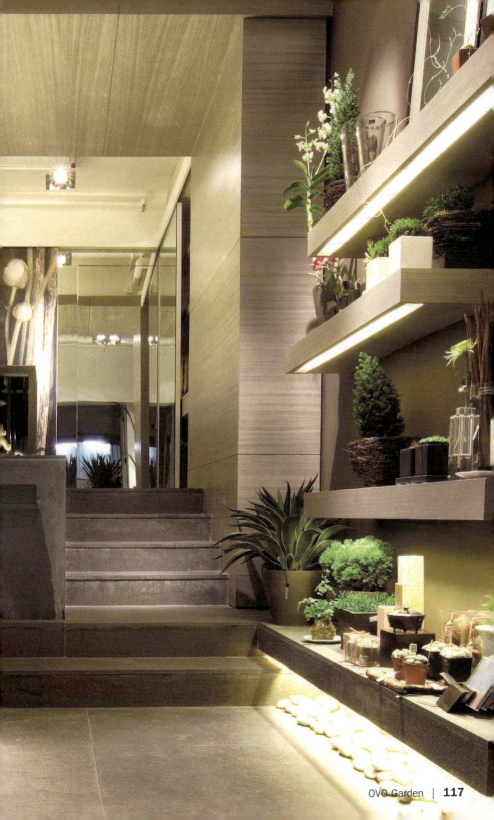

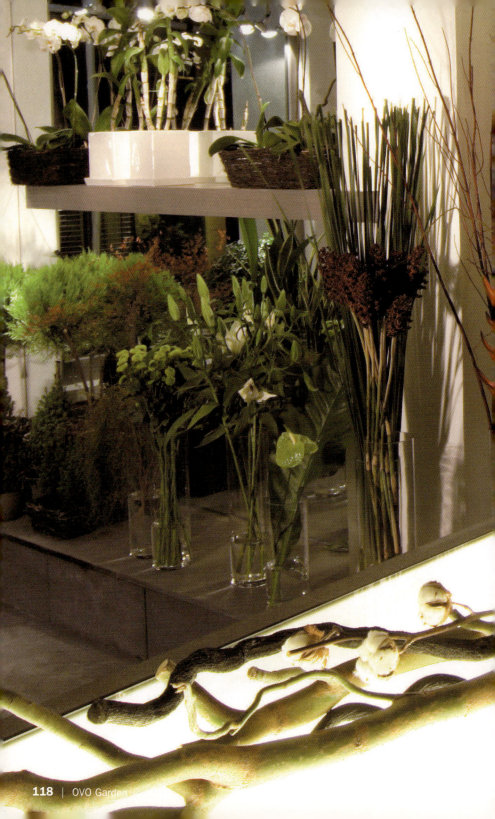

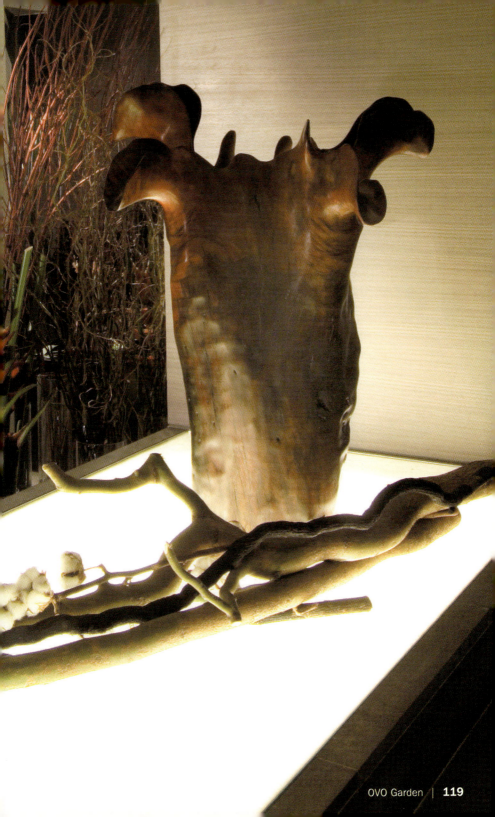

Pink Box
Flagship Store

Design: Colin Chan, Pal Yu, siDE Architects

Shop 101C, Maritime Square | Hong Kong | Tsing Yi, New Territories
Phone: +852 2435 5530
www.pinkbox.com.hk
MTR: Tsing Yi
Opening hours: Every day 11:30 am to 9:30 pm
Products: Jewelry

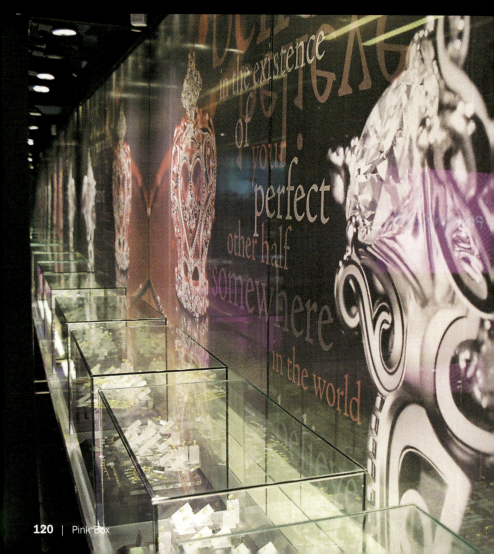

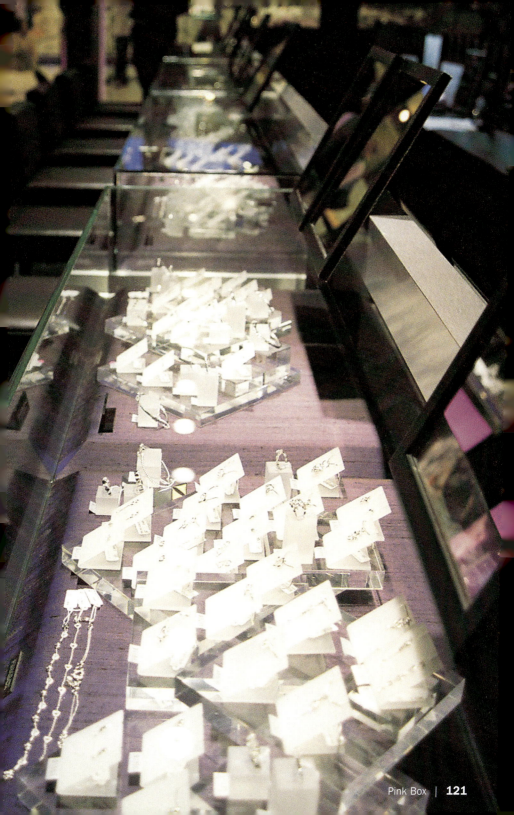

Shop 1060, ifc mall, 8 Finance Street | Hong Kong | Central
Phone: +852 3188 4403
MTR: Central
Opening hours: Every day 10:30 am to 8:30 pm
Products: Cosmetics
Special features: Private consultation room

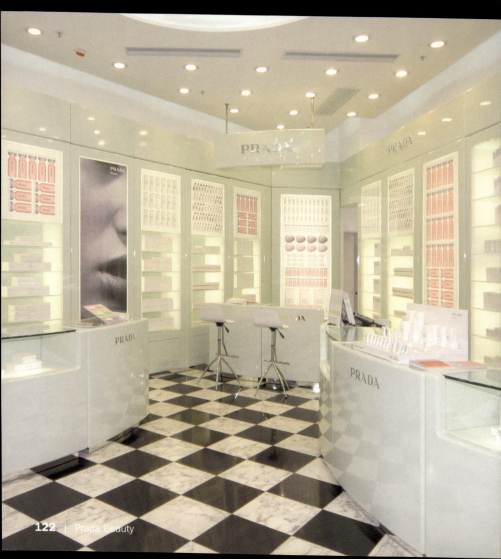

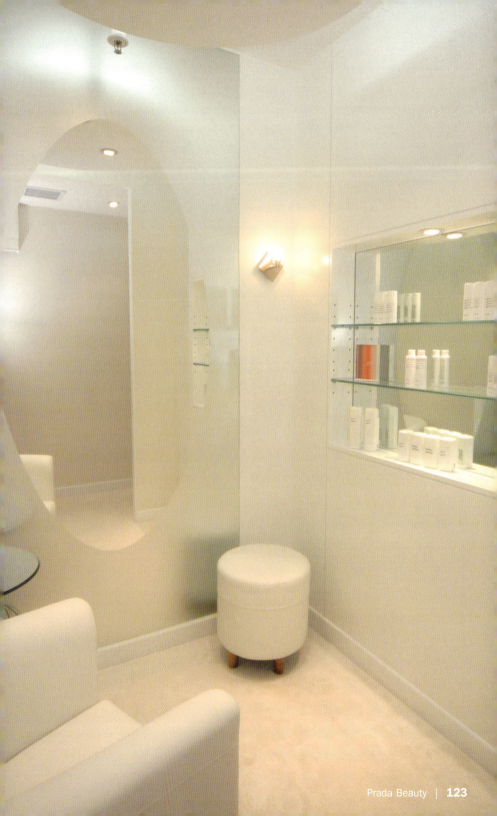

Qeelin

Design: Steve Leung

BL6A, The Peninsula Hong Kong, Salisbury Road | Hong Kong | Kowloon
Phone: +852 2368 1328
www.qeelin.com
MTR: Tsimshatsui
Opening hours: Every day 10:30 am to 7:30 pm
Products: Luxury jewelry
Special features: Qeelin is China's first luxury jeweler

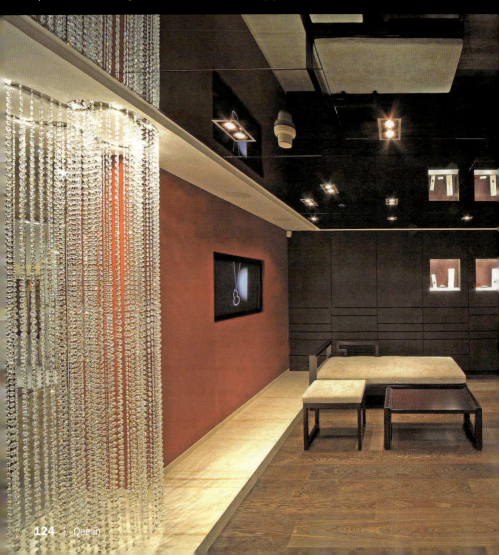

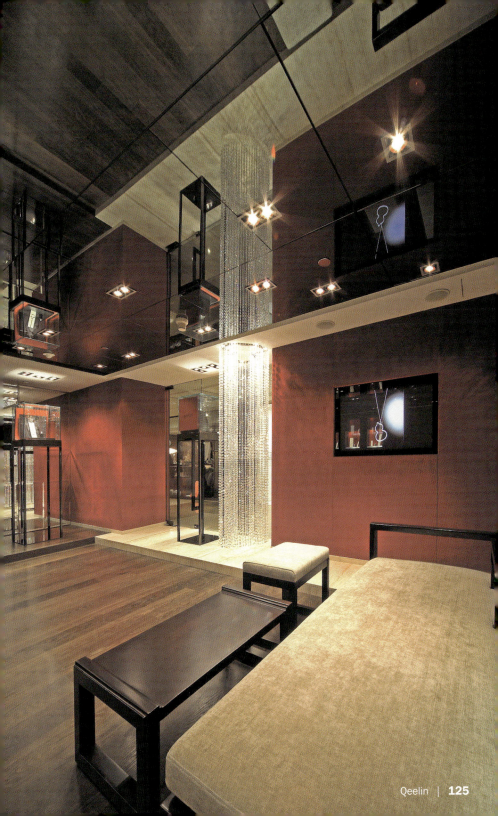

Seibu Langham Place

Design: William Lim

8 Argyle Street | Hong Kong | Mongkok
Phone: +852 2269 1888
MTR: Mongkok
Opening hours: Every day 11 am to 11 pm
Products: Men's wear, women's wear, skin care, cosmetics, fashion accessories
Special features: Young shoppers paradise

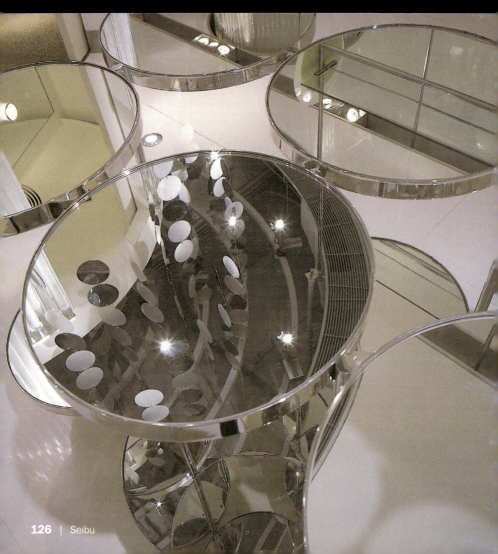

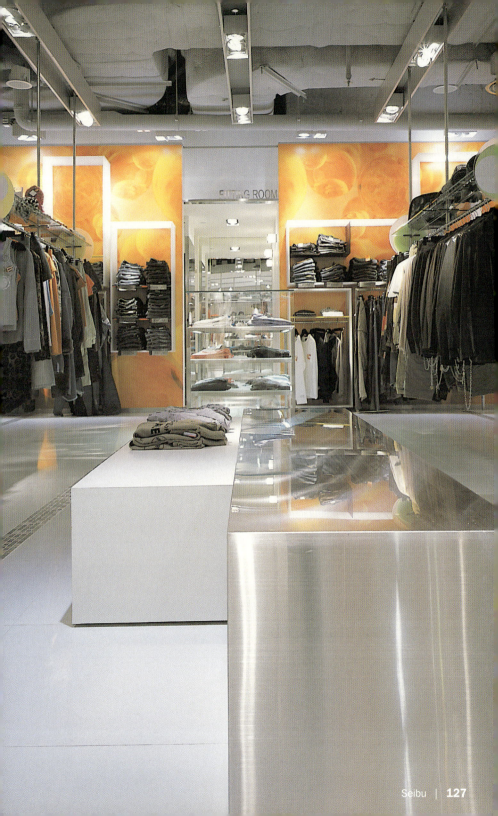

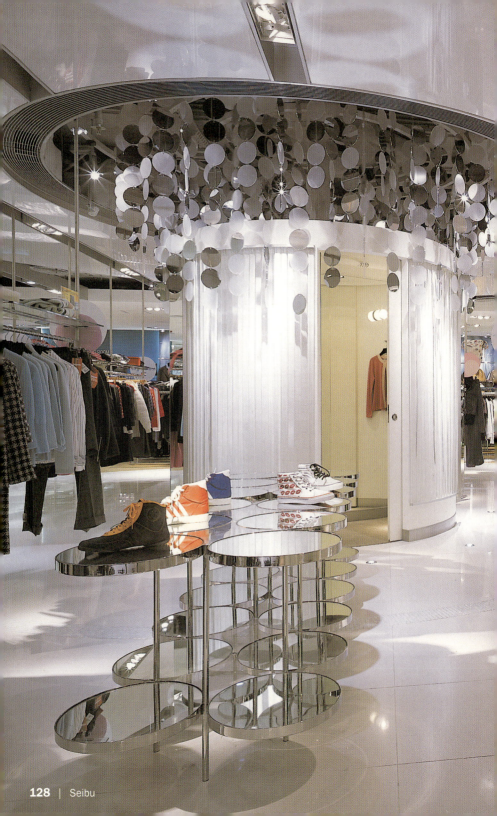

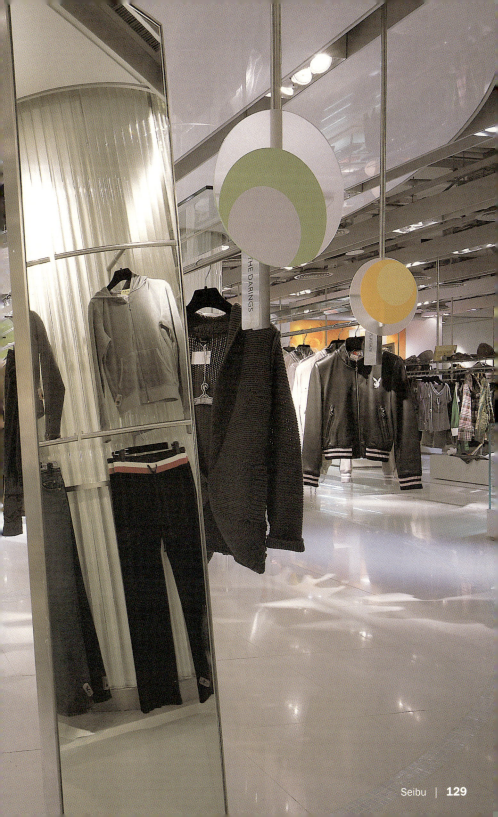

Swank

Design: Atelier Pacific

Shop L103-113, The Place, New World Centre | Hong Kong | Tsim Sha Tsui
Phone: +852 2735 0842
www.swankshop.com
MTR: Tsimshatsui
Opening hours: Every day 10:30 am to 7:30 pm
Products: Women's and men's fashion and accessories
Special features: Folding and sliding shoji glass screens are re-configured for 'catwalk' events and trunk shows

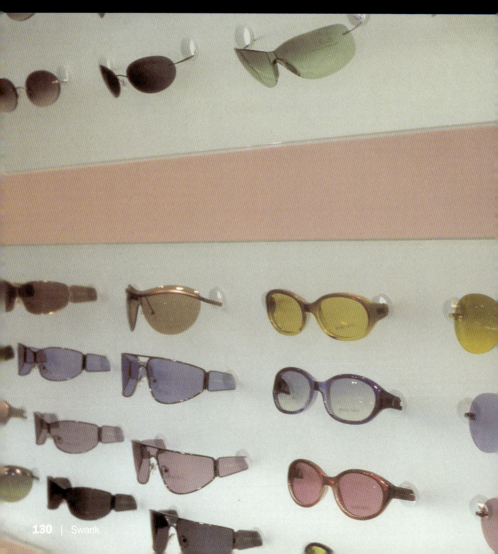

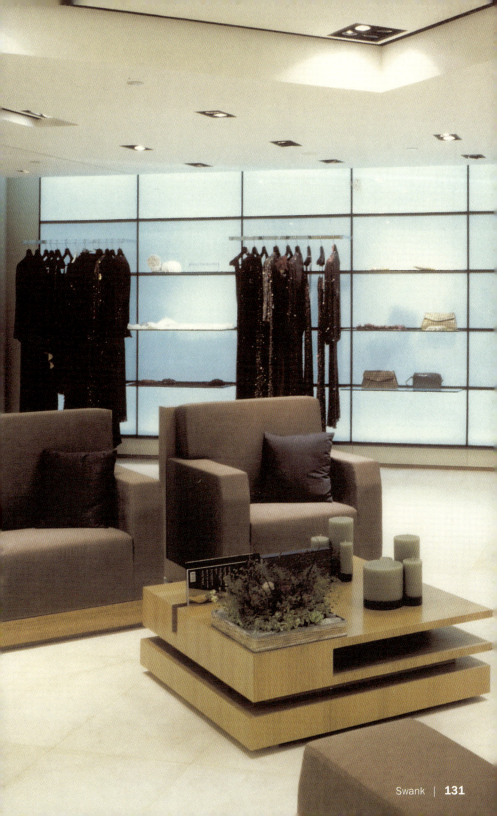

SWANK) 詩韻

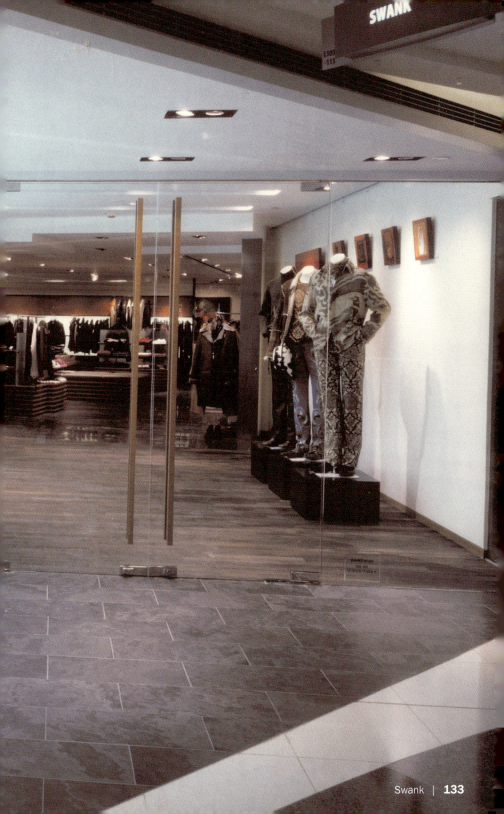

No.	Shops	Page
1	Aesop Concept Shop	10
2	Arnhold Designer Gallery	14
3	Artistic Palace	16
4	Barrie Ho Collections	20
5	Basheer Design Books	22
6	Bloomsbury Bookshop	28
7	Dialogue	32
8	Emphasis Jewellery	38
9	Emporio Armani Chater House	42
10	Eu Yan Sang	50
11	Evisu, ifc mall	54
12	Galerie Vee	56
13	GOD	58
14	Graham 32	60
15	Habitus	62
16	Harvey Nichols Store	66
17	I.T Pacific Place	72
18	Joyce	74
19	KOU	78
20	Lane Crawford, ifc mall	84
21	Libre!	90
22	Louis Vuitton	98
23	Louvre Gallery	102
24	Maybach Centre of Excellence	106
25	Momento	108
26	On Pedder	112
27	OVO Garden	116
28	Pink Box Flagship Store	120
29	Prada Beauty, ifc mall	122
30	Qeelin	124
31	Seibu Langham Place	126
32	Swank	130

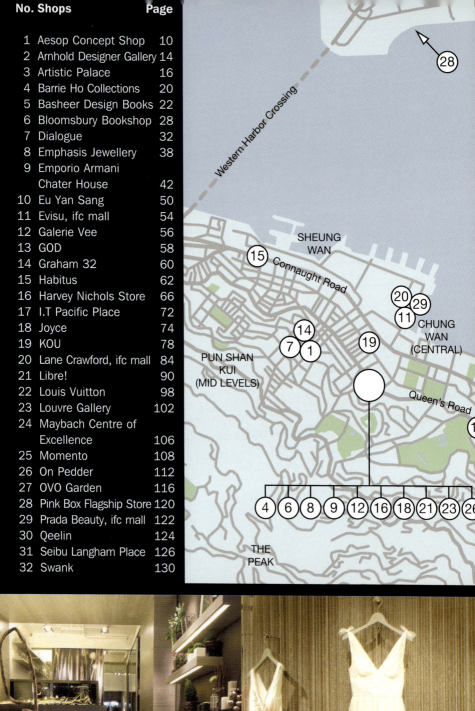

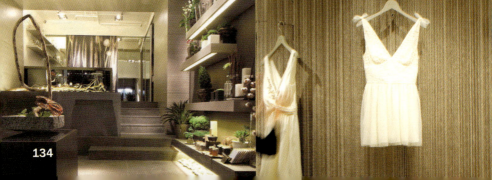

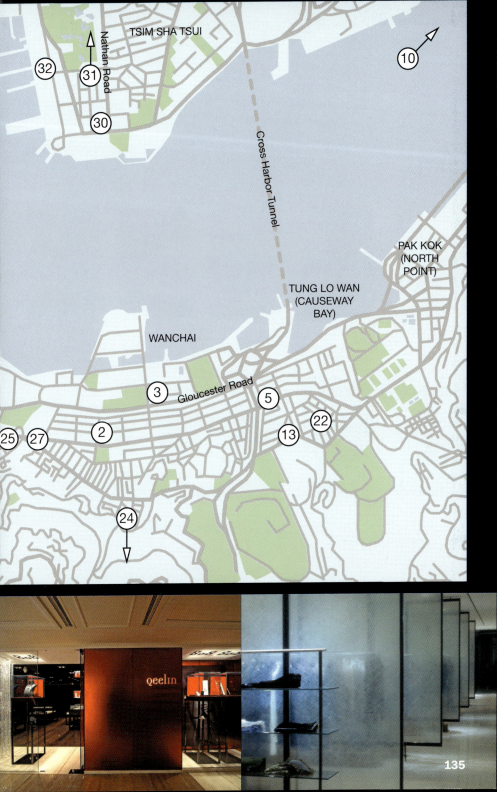

COOL SHOPS

Size: 14 x 21.5 cm / 5 ½ x 8 ½ in.
136 pp
Flexicover
c. 130 color photographs
Text in English, German, French, Spanish and Italian

Other titles in the same series:

ISBN
3-8327-9073-X

ISBN
3-8327-9070-5

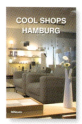
ISBN
3-8327-9120-5

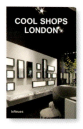
ISBN
3-8327-9038-1

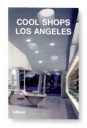
ISBN
3-8327-9071-3

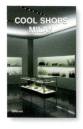
ISBN
3-8327-9022-5

ISBN
3-8327-9072-1

ISBN
3-8327-9021-7

ISBN
3-8327-9037-3

ISBN
3-8327-9122-1

To be published in the same series: Amsterdam San Francisco
Dubai Shanghai
Madrid Singapore
Miami Vienna

teNeues